Quiet
Perseverance

Quiet Perseverance

30 LESSONS FROM AN INTROVERTED
OUTSIDER'S DAUGHTER

VICTORIA LIU

Proofread and edited by Victoria O'Dowd
Illustrated by Tamas Paszto
Formatted by UK Design Company
Printed and bound by CLOC Book Print

BOUNDLESS
INK BOOKS

To my beautiful niece:

Grandpa would have loved to have known you.
I hope these stories tell you more about who he
was – as a man, a beloved father and a teacher.

To every girl who doesn't feel they belong:

You are born perfect;
you have always been –
and will always be – enough.

Contents

Advance Praise for *Quiet Perseverance*

'In Victoria's writing I can see, and feel, the richness of a life of experience. Her words touch my inner six-year-old and my current more advanced years. The stories in the book have the ring of truth and leave me with a sense of wonder at the way life's lessons have been learned by her, along with some reassurance that perhaps I have also learned from my own life. I delighted in every story.'

Steve Dilworth, author of The Heart of Facilitation

'In *Quiet Perseverance*, Victoria Liu bares her soul, offering a rare glimpse into the struggles faced by introverted immigrants in the corporate world. It's a story that needed to be told.'

Associate Professor at Harvard Business School

'Victoria's courage in sharing her experiences with bullying and harassment is commendable. Her story is a beacon of hope for those silently struggling in toxic work environments.'

MG, Event Manager at a five-star hotel chain

'Victoria Liu's *Quiet Perseverance* leaves a long-lasting impact. Her writing provides such relevant and inspiring insights, which are anything but quiet! Liu's lessons are at times raw and thought-provoking and her journal-prompt questions give the reader a chance to reflect and consider their own leadership journey.

This book is required reading not just for leaders, but also introverts, people who identify as neurodivergent, and those seeking to foster inclusive leadership within their organisation. An incredible piece of work.'

Judith Underhill, Founder, Underhill & Associates Ltd

'Victoria shows us how hardship produces perseverance, character and hope for the future.'

Selana Kong, Intercultural Communication and Negotiation Specialist

'In *Quiet Perseverance* Victoria recounts her struggles and challenges with raw honesty and humour. Her memoir about self-discovery and growth is a must-read for anyone who has ever felt like an outsider.'

Executive Director of a global investment bank

'Victoria shared her experiences with vulnerability and helped me create a new perspective in life; she is the Asian Brené Brown. She understands and bridges the challenges we have from our cultural upbringing and unique nuisance of how shame is deeply embedded in the Asian culture (we have more than 100 different terms and phrases related to shame vs. only 1 in English). Her experience as an immigrant resonated with many of us. I now run my business with more ease, making seven figures consistently, and not only am I working less, but I have also rediscovered my passion. I have just taken my first two-month holiday with my kids and they are so happy that they have their fun mum back.'

Grace Lee, Founder of Joyful Movement

'Victoria's raw honesty in *Quiet Perseverance* is inspiring. Her journey resonates deeply with anyone who's ever felt like an outsider. As an immigrant who made it to the C-suite, I wish I had this book years ago. Liu's lessons are spot-on and her strategies are immediately applicable. A powerful guide for turning cultural differences into leadership strengths.'

Belinda Spear de Erney, Founder & Principal, Metagnosis Consulting Inc.

'Liu's personal journey is a stark reminder of the human experiences behind diversity statistics. This memoir should be mandatory reading for every corporate leader.'

JL, Strategic Partnership & Business Development, Google

'Victoria's book is a beacon for introverted women in leadership. It's empowering, practical, and challenges the extrovert-centric norms of corporate culture. I'll be recommending it to all my mentees.'

Michelle Tan, Head of Talent Acquisition at a Big Four accounting firm

'Victoria Liu's *Quiet Perseverance* offers a rare insight into a fascinating childhood experience, clearly a crucial component in the creation of a high-performing woman whose extraordinary achievements speak for themselves. Victoria has brought together a collection of powerful and actionable lessons, compellingly written and shared with compassion and pragmatism. I can say with confidence that there are useful lessons for each and every one of us in the pages of this beautiful book.'

Will Harvey, Managing Partner at Zenith Leadership Ltd

Preface

My father was a remarkable man. I could never have achieved even a fraction of my personal and professional milestones without the lessons he taught me. When I graduated with quadruple majors (double conjoint bachelor's degrees) with a scholarship at the University of Auckland, it was because of the lessons I had learnt from him: discipline, focus and perseverance; to triple-stack my day with good habits; to eliminate all forms of distraction; to fight for every opportunity and chase every dream. When I became the first Chinese female chief of staff at Deutsche Bank, it was the result of decades of hard work and self-sacrifice driven by the man who gave me my backbone, my determination and my drive.

Both my culture and my father's struggles inspired me and taught me to be the best I can be. My brother and I are his greatest achievements. But that doesn't mean we had an easy time. For much of my early life, we didn't have a lot to spare: every treat had to be earnt and hard work was part of our daily lives.

I probably grew up in a different era and a very different place from those of many of my readers. The Hong Kong of my childhood doesn't exist any more. I was an immigrant during much of my education and that made me an outsider: a small girl who didn't have the language to express herself but who had the brains and the work ethic that she needed to become much more.

At times, Dad's advice might seem out of step with today's norms; it might feel very prescriptive or authoritarian; it might occasionally verge on what you might call bullying or controlling. I make no apology for this and I'm sure he wouldn't have either. He was the son of poor Chinese rice farmers, and he moved to Hong

Kong, and later to New Zealand, to better his life and to improve his children's chances of a bright future. He wasn't going to let anything get in his way.

I went on to achieve so much more than anybody could have predicted for that little Chinese girl with few friends or connections. I'm proud of my achievements – but I owe everything to my dad. Some of his lessons were harsh, but he only ever wanted the best for me and my brother. The lessons I acquired are not universal – they won't work for every reader – but I hope there are a few that will help each person to achieve their potential.

I wrote this book to help you to discover that you are not alone, however much of an outsider you might feel, and to show you that you can create and find a community if you are willing. I never thought I would have the courage to share my stories, but with the encouragement and love of my friends, my mentors, my clients and my network, I overcame my fears and did it anyway. I hope my story will provide you with the support you need in your own personal journey.

Thank you to everyone who encouraged me to be open and vulnerable about the trauma I experienced. For a long time, I kept these thirty stories private; I felt too ashamed to speak out loud. Thank you for being part of my community and a compassionate witness to my healing and recovery from trauma. I hope my stories will also bring you some relief and show you that you are not alone. In my experience, and as I'm sure you will discover, there are people out there who will love to help and support you in your journey of self-discovery.

My grandfather was a calligrapher, and I was the only grandchild of thirteen who inherited his love of the craft. Throughout this book, all of the titles and scripts are inspired by my calligraphy and drawings and reflect many unique Chinese themes and influences. Feel free to

drop me a line to let me know what you spotted and what resonated with you and your own culture.

I imagine you reading this book in any way you like. You can read from the beginning to the end, in the order I wrote it, or in a non-chronological way. Why not try opening the book on a random page and see what you are called to; I believe the story will support you in the way you need. Or just scan the headings and illustrations to see what appeals to you and go from there. There is no right or wrong way.

For those who love to journal, and who would like to reflect on the lessons, I have created a companion journal. You can go to my website and download it as a fun supplement. At the end of my book, I have also provided some resources that I have found to be beneficial to me and my coaching clients. Please use them and share them with your friends, family, book club or anyone you think will benefit. In doing so, I'd really appreciate it if you could tag me – #quietperseverance or @victorialiucoach – I'd love to see how these resources are helping to support you in your journey through life.

I'd also love to hear how my lessons have resonated with you and how my experiences might have helped you. Feel free to connect with me via LinkedIn, Instagram or TikTok, or join my community on www.victorialiu.com and stay in touch with my learning journey.

Thank you for choosing my book; I hope you have as much fun reading it as I did writing it.

With deepest gratitude,
Victoria

Introduction

This book is a collection of short lessons that reflect upon my journey and experiences: how I overcame obstacles and learnt to pick myself up in the foreign country I now call home.

I wish I'd had this book when I was in my twenties and thirties, when I felt lost, stuck, anxious, frustrated, and was standing at the crossroads of uncertainty. 'Should I focus on looking for a better job and risk not delivering 150% in my current job? Should I stay and try to build a better network for greater opportunities in-house, or should I pivot and try something entirely different?' I asked myself these questions all the time, and no one could help me.

I didn't know what I didn't know; I didn't know where to get help, what help I actually needed and how to ask for it. I didn't know that my own superpower could become my kryptonite.

I hope this book will help you to identify your superpower and enhance it, so it will empower you and enable you to shine so you too can achieve the success you desire – whatever it is, whatever form it might take and no matter how you define success.

This book does not promise to remove all of your anxiety, anger, confusion, frustration and stress, but I promise that it will reduce it and give you the encouragement and energy to focus on what truly matters to you, preventing you from falling down the rabbit hole of angst and inaction. Maybe it will enable you to have more me-time, more time with your family and loved ones, fewer sleepless nights and financial worries, a greater balance between your home life and working life. Or it might simply allow you more time around your kitchen

table in the evenings spent sipping your decaf vanilla macchiato while scrolling Instagram reels or laughing with your partner while the children are upstairs asleep.

SO – what are you waiting for? Join me in this journey of self-discovery and reflection and begin creating your best life.

Part

1

From the Beginning

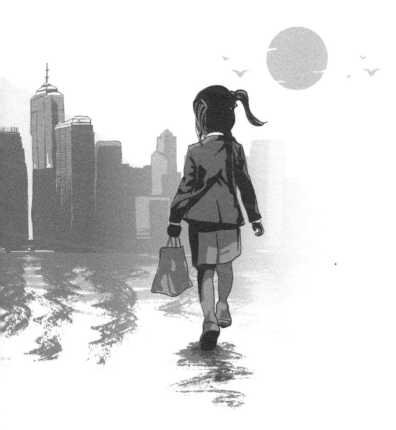

CHAPTER 1

Patience

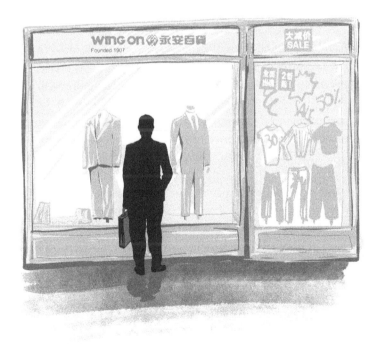

One of my dad's most treasured items was a burgundy silk pyjama suit with small beige dots. It had delicate beige buttons down the front and a timeless V-shaped collar. He told me that he bought it in 1960 and it cost him 100 Hong Kong dollars.

I have heard this story many times. Dad first saw it in the window of the Wing On Department Store 永安百貨 in Sheung Wan, Hong Kong. At the time, he was an assistant at a small textile company, where he ran errands for the owners. It was a tough job; he was making ten dollars a month and sleeping in the attic of the factory. He said it was the shortest ever commute to his workplace! Every month he put aside each dollar he could spare, and whenever he walked past Wing On, he would check that the pyjamas were still there. He would gently touch the soft silk and imagine what it would feel like to wear them.

It took him almost two years to save the money. In fact, he saved far more than he needed, but he wanted to have a buffer of savings before he splurged on his dream purchase. When he finally stepped inside the store with the cash in his trouser pocket, in his own classic style he had already made friends with the sales assistants, who all recognised him and ended up giving him a small discount.

Dad always taught me that when you make ten dollars, try to spend only one dollar because you never know when your next pay cheque will come in. Only fools rely on expectations of regular money and spend what they haven't earned yet.

Those silk pyjamas he bought in 1960 were still in immaculate condition when he passed away in 2019, except for one missing button – quality lasts.

Dad taught me that it's worth taking the time and making the effort to buy something you will treasure, and I learnt from him that the reward is even sweeter when you have dedicated your time and patience to achieving it.

I have taken care to live by his philosophy about saving money and buying quality. I worked hard and saved for a long time to buy my first fancy wristwatch, a Tag Heuer. I was drawn to their motto: Don't Crack Under Pressure. I earned that money with two solid years of tutoring every evening, and each time I look at the watch it reminds me of what my hard work, resilience and determination achieved. High performance, precision, mental endurance and fortitude. As their campaign tagline said at the time: Success. It's a Mind Game.

I spent three years working full-time at the Australia & New Zealand Bank (ANZ) to earn my professional accreditation in Lean Six Sigma Black Belt, a global certification recognised by many Fortune 500 companies as one of the best practice tools for process-management frameworks. Comprising multiple levels of competency and expertise, it uses the colour-belt ranking system commonly used in martial arts.

Black belt certification demands a level of demonstrable expertise, including mastery of methodologies, statistical tools, mindsets, principles and leadership capabilities to manage multiple teams focusing on diverse improvement areas. It also covers mentoring approaches, coaching techniques and performance-feedback management. Thousands of companies across a diverse range of industries rely on its tried and tested methods to ensure their people, processes and products are in a continuous state of improvement.

This training equipped me with valuable skills to help companies deliver high performance consistently and sustain their competitive advantage while optimising profit margins, improving process efficiencies and, most importantly, keeping staff motivated and productive.

When I moved to the UK, I funded myself through different courses to give myself a broad and

diversified set of skills. These have allowed me to pivot and forge different career paths as opportunities have arisen, paths ranging from business analysis to project management, stakeholder management to multi-country change programmes and technology-implementation programmes.

I have delivered more than 10,000 hours of coaching, mentoring and training workshops, and have completed advanced diplomas and master's degrees from Cambridge University, Yale, Harvard and MIT. My subjects have included applied positive psychology, neuroscience and leadership, conflict management, and negotiation mastery. Through my endeavours, I obtained the Global Certified Master Executive Coach qualification from the Association for Coaching. (At the time of writing, there are fewer than 100 of us in the world who have attained this level)

My father understood and applauded each of my investments. Every dollar I have spent on education and self-development has returned ten times the value for my mind, my knowledge and my future. Continuous investment in my own professional development has been the core foundation in supporting my clients with the latest research and applications.

Do you invest in your own professional development? Successful leaders tend to spend, on average, at least 10% of their net income on professional development: books, seminars, courses, subscriptions to journals, etc. Most of my clients who are ranked in the top 5% of their respective organisations have spent around 15% on executive coaching, while their companies provide further tailored support specific to their roles: technical training, latest research conference and other in-house programmes. What would you

love to learn? How would you invest in your own future development regardless of whether your current employer is able to support you financially?

CHAPTER 2

Intuition

I grew up in countries with democratically elected governments and I took a lot of my rights and privileges for granted. I certainly didn't realise how lucky I was or how different my experience was from that of my parents. I trust people quickly and wholeheartedly, but that was not my dad's way. He would tell me that only lucky or foolish people are naïve enough to trust others so easily. I used to wonder why he was so paranoid and fearful.

My dad, however, grew up under a Communist regime where he learnt, at an early age, to be wary of others and that hard work doesn't always deliver the right results. Just because you work your own land doesn't mean that your rice and your profits are your own. The Chinese government could take whatever it wanted, whenever it wanted. It was a highly demotivating system to a hard-working, ambitious man like my dad. Feeling insecure about his property, he left China in the 1940s to settle in the place he saw as the Land of Opportunities – Hong Kong.

His fierce sense of independence came from both his fear of losing his property and his reluctance to trust others. He told me that in his youth it was common to discover that your neighbours, friends and even your family might be 'snitches', passing information to the government. He couldn't assume that anyone was trustworthy. Trust had to be earnt and was not given lightly.

He turned his wariness into a game and taught me personal codes that represented different things. For example, he would always call, let the phone ring three times, hang up and then call again, to let me know that the call was from him. When I answered, he would ask me to tell him about my surroundings. We had safety words so that I could tell him if I was in trouble or if I needed help. I was to put my shoes and those of any visitors outside

the door to let him know who was there and what was going on inside. When I was young, I found these code games amusing. It wasn't until much later that I came to understand why he had taught us these things.

He also taught us sign language and the Hakka language to ensure we had our own secret family codes, so we could let him know when something was wrong without alerting those around us. I wonder if you have a secret family language or special code?

It was as though Dad had an innate sense of inner trust and confidence in his abilities. Perhaps it came from his teenage years of surviving in a foreign country without his parents or guardians. He knew that, whatever the problem, he could figure a way out. His 'spidey sense' of others' motives was incredibly accurate and his judge of character was astonishingly spot on.

He taught me about body language, so that I could observe the smallest details and changes in facial expressions and know if someone was distracted or feeling uncomfortable. It's been phenomenally helpful in my career. I can watch my team and pick up on distress signs and potential issues before they become a problem. I'm also great at solving crimes in movies before the plot is revealed!

His brand of paranoia turned out to be hugely beneficial when we were burgled during our first year in New Zealand. He noticed that something was wrong the moment we arrived home from the supermarket. The second we were inside our house, he rushed to the master bedroom and took out a burgundy calfskin briefcase that was covered by a pillowcase and wrapped in sheets. I hadn't seen this briefcase in years and had forgotten all about it. The look of relief on his face told me that it contained something really important. Gingerly, he rewrapped it and placed it back in the wardrobe.

I wondered what was inside that case.

I learnt that what I used to call paranoia is actually my intuition giving me a direct message via my body to be wary and protect myself. Trust your senses and trust your body. Pay attention to these signals – your body is as wise (if not wiser) than your brain; it holds the secrets to many generations of wisdom if you are willing to listen.

What embodied intelligence do you rely on to connect to your instincts? What can you do to improve your connection to your body and your gut?

CHAPTER 3

Shame

Watching my friends' young children now that I'm an adult, I realise I made a lot of judgements about childish misbehaviour. Kids will kick, scream or cry until they get what they want, whether this is another scoop of ice cream, the latest toy or to go outside and play. I would become frustrated and impatient, wanting to ask parents to calm their kids down and control their behaviour. I'd even feel angry at a nice restaurant when children were running around, making noise. It took me a long time to realise that my anger was driven by jealousy because I had never had the chance to act like those children.

From the earliest age I can remember – maybe three or four years old – I was told that if I didn't behave, I would never be taken out of the house again. And I believed every word of that threat. When we were out, I was expected to stay close to my parents, not make a noise, only speak when I was spoken to and never interrupt when my parents were talking to other people. If I needed special attention, such as going to the bathroom, I would give Mum or Dad the appropriate signal I had been taught to indicate my needs and then sit quietly, waiting for their response. One of them would either respond swiftly or tell me to wait, and I would continue to wait patiently, knowing further interruptions would not be acceptable.

The only times we went out, other than to school and church, were for outings to the zoo or the park, and to weddings and parties. Mum and Dad made it very clear that such trips had to be earned through good behaviour. Consequently, we did not cry, scream or kick because causing a scene was an absolute no-no.

My parents did not believe in public shaming; they would treat me with respect in front of other kids and adults, but once we were home behind closed doors, they would make it clear to me that whatever had happened earlier was unacceptable and tell me what I should have

done instead. This further refined the secret codes and what was expected of us to keep the family's face.

One time at a wedding banquet, I was sitting quietly with my brother, close to our parents. We continued to sit still until we were told we could return to the main area to eat. All of the adults were telling our parents how impressed they were that we sat still and didn't interrupt, that we were so polite and quiet. The recognition and praise those adults gave us were powerful motivators to encourage me to keep behaving like an obedient child, a good girl, even though I thought I was behaving like an adult!

Dad reinforced our good behaviour by pointing out other kids who were running around playing hide and seek. Shaking his head, he would tell me how naughty they were, and how much shame they brought to their parents. I was programmed not to bring shame upon my family. I would have loved to play with the other kids, but I didn't dare to ask, and when they asked me to join them, I didn't dare to accept. I knew that if I misbehaved or disobeyed, my dad would use the bamboo stick that stood on the top shelf. Four decades later, whenever it caught my eye, the stick would remind me of the importance of obeying and not bringing shame on my family.

Whatever the positive intentions of my parents, using shame to motivate us to behave well unintentionally created negative consequences for my adult life. It took many years of studying Brené Brown's work, and other self-compassion advocates, such as Tara Brach and Kristin Neff, for me to gain an understanding of how all this had impacted my life. Brené Brown has helped me to understand many of my emotions, in a gentle and empathetic way, whereas Tara and Kristin have provided me with a set of tools to become more aware of my triggers and my responses, and to help me develop deeper

self-worth, empathy and compassion.

'Shame cannot survive being spoken. It cannot tolerate having words wrapped around it. What it craves is secrecy, silence, and judgment. If you stay quiet, you stay in a lot of self-judgment.' Brené Brown

Integrating Brené Brown's work on shame with Richard Schwartz's work on Internal Family Systems, I now take my shame out for a walk, in the sunlight. I named my shame Dr Cristina Yang, the character in *Grey's Anatomy*, and have conversations with her when I feel ashamed. This way I can stop focusing on the self and concentrate on the part of me that feels the need to shame me, in order for me to be a better human being.

How was shame created in your childhood? Has it served its purpose now that you are an adult? Where does it show up in your day-to-day life? How can you befriend this part of you, so you can be kinder to yourself and be more present and aware of its impact on your behaviour?

CHAPTER 4

Presence

In almost every black and white photo I have of my dad, he looks smart. Usually, he is wearing a crisply ironed white shirt (sometimes with a tie), dark suit trousers and a polished belt. Even in a photo of him playing badminton with his friends he was wearing a suit!

My mum said that Dad dressed better than his boss, and many people used to mistake him for either the boss or the boss's son. So, I asked him why he dressed like that.

He said, 'It's important to be well presented and to always dress for the job you want, not the job you have.' Good personal grooming was absolutely non-negotiable in the Liu family. Dad said, 'If your nails are chipped, your fingers are not clean, you smell of sweat and your hair is greasy, an observer can only wonder what else you might be neglecting in your professional life. How can anyone trust you as a professional if you can't even look after yourself and your hygiene?'

As a migrant from China, he worked on his accent to make sure he didn't sound too 'foreign' to the sophisticated people of Hong Kong or give others an excuse to laugh at him for being a country bumpkin (my grandparents were rice farmers). He told me, 'People judge you from the way you look in the first three seconds, and it takes years to change that judgement. Investing in making a good first impression means that others don't have an excuse to look down on you. You don't have to wear expensive clothes, but they do have to be well fitted and clean, with no fraying edges or stains. Make sure you are always well presented and well groomed because you never know whom you might encounter in the lift.

'Buy the best quality classics that you can afford. Buy fewer pieces but invest well. Save for quality and elegance and avoid temporary fashion trends. No one will comment on a classic coat that you wear for twelve years, but someone will comment if you wear the highest

fashion from last year.'

Dad taught me that it's OK to save for things that you will enjoy for a long time. Just make sure you always look after your clothes and they will look after you.

I once asked him if he thought he was vain. Dad never said he wasn't vain; he just said his desire to look good kept him at a much higher standard of presentation than most, and he was certain that many of his opportunities would not have come along had he not had his presence and high standards.

Many years later, when I was promoted to VP, I rewarded myself with an iconic Dior Bar jacket and trousers in navy. This power ensemble became one of my most valued and trusted suits of armour. Putting it on, I was immediately filled with the confidence of a successful corporate woman. I would stand tall and speak with conviction. I felt like I owned the room when I wore this power suit.

Sometimes the best-dressed bird gets the worm.

CHAPTER 5

Accountability

In Hong Kong in the 1980s, when I was young, Happy Valley was a quiet area without the energy and buzz of the bigger districts, like Causeway Bay or North Point. We lived on a quiet street and because there was no subway station, the only way to get to Central Hong Kong by public transport was to take the bus or the tram. Having a car was a handy alternative for our family to get around.

Dad drove us around in a yellow Toyota, but he also used it to make money, giving driving lessons to local wealthy housewives. He would joke that our neighbourhood had far more fancy cars than people with the skills to drive them properly. Seeing an opportunity to put that right, my creative father got an instructor's licence and set up his own driving school.

He was very popular and usually overbooked, with a waiting list of potential clients. The housewives of Happy Valley loved to learn from Dad. He made all his students feel safe and he was very patient with them. He was charming and always made little jokes to keep the atmosphere relaxed. Whenever we saw any of his driving students in the local bakery or restaurants, the ladies' husbands would thank my dad for giving their wives such confidence behind the wheel and for helping them learn. I never saw him teach, but I do know my dad was very calm under pressure. He said it was his responsibility to watch out for imminent dangers while giving the students enough space to learn. In that way they learnt to trust themselves behind the wheel.

Dad also took great pride in ensuring that his car was always well maintained for his students – not just the standard oil change but also a clean interior. He even had special cushions for students who needed more support for their backs. Of course, we children had our roles to play in keeping the car clean for his students.

Dad didn't believe in pocket money. We never got

any kind of allowance, and the red envelopes of money that we would receive from relatives during Chinese New Year, and on other special occasions, were taken and kept for us for the future. While there were no handouts for just being children, Dad would encourage us to work for money, and one of the jobs on offer was to help him clean the interior of the car.

When I was eight or nine years old, I could earn two Hong Kong dollars by helping to dust the covers of his car seats every Sunday morning after church. I would also clean the carpets while Dad washed the outside of the car.

One Saturday afternoon, Mum made us an offer I couldn't refuse. She said that if we finished our school homework before bedtime, she would let us watch one episode of *The Smurfs* on television after church on Sunday. This was a real treat. Our normal TV allowance was to watch the thirty-minute evening news. My brother and I raced to the dining table and quickly took out our schoolbooks. The idea of television was so attractive that I totally forgot I had promised to help Dad with his car.

On Sunday after church, Dad started getting his tools to go to the garage while we sat excitedly in front of the telly, waiting for Mum to turn it on. Dad looked at me and said, 'What are you doing? Are you coming?' I quickly realised that I had to choose between *The Smurfs* or two dollars. Young Victoria chose *The Smurfs* and told Dad – without even looking up – that she wouldn't be taking the two dollars, thank you.

Dad asked me again if I was coming. 'No,' I replied, and he left the house alone.

A few hours later he came back inside, and I brought him his slippers. He was very cold towards me. Eventually, he asked me what I thought an agreement meant. He said it wasn't about the two dollars, it was about

a promise to deliver, and if I couldn't deliver then I should have told him earlier so he could have made alternative arrangements. I should never have let him down at the last minute with so little respect and consideration for my 'employer', regardless of how much I was to be paid.

I felt so ashamed that night. That was the last time I helped Dad wash his car. He said that if he could not rely on me, I was not the type of worker he could pay. He never gave me the chance again.

It was a tough lesson – and one that stayed with me. I learnt not to let people down regardless of how much I was being paid – or even if I wasn't getting paid at all. I learnt to give others plenty of notice if my circumstances changed. I learnt not to over-promise if I couldn't deliver, and to treat each commitment with respect.

I also learnt that trust must be earned and, once violated, it is very difficult to restore. With his driving students, my dad spent a lot of time cultivating that trust so they could feel safe as they grew in confidence behind the wheel.

CHAPTER 6

Competition

When I was little, I used to fight with my older brother all the time. Mum said she didn't know where it came from, but I was naturally very competitive. I wanted to do everything he was doing; I wanted to read the same books as him and I wanted to follow him everywhere. On the other hand, he found me a nuisance and tried to get rid of me all the time.

I even have a scar on my forehead from when I was two years old, when I fell down the stairs at a branch of the Hang Seng Bank, the pickup point for my brother's school bus. My brother said he was thirsty, and I ran up to the bank to get him water in a little cone-shaped paper cup. As I turned around and saw that he was about to get onto the bus, I was so determined to reach him with my little cup of water that I didn't realise how short my legs were. Alas, little Victoria tripped and rolled down the stairs, spilling all the water, which mixed with blood from my forehead.

Mum decided to harness my desire to be as good as my brother and used it to challenge our learning – whether it was in playtime or while studying. She would buy two of the same LEGO set that we had wanted all year and she would give them to us as a reward for good behaviour on our respective birthdays that year. She would then watch how quickly I could build it next to my brother.

With me sitting next to her, she would revise my brother's mathematics exercises, and I would watch and mimic, quietly learning material that was three years in advance of my age. Eventually, she would make us do speed drills to see who could do their times tables the fastest. I was faster and more accurate than my brother when I was four and he was seven, but, physically, I was much smaller and shorter than him. So, when we had a physical fight or raced around the football fields in Happy Valley with Dad, I always lost. Mum kept telling me that

it was OK, that I had shorter legs and couldn't kick as far as my brother. But Dad wouldn't have it; he challenged me to use my brain to make up for what I lacked in size. He would say to me, 'What unique resources do you have that your brother doesn't have? What can you do that he would never anticipate?'

I was shorter but I was faster and more agile. I was hyper-flexible, and I could roll and hide more easily. I might not have been as strong but I had other talents. I would say that if my older brother was a Tyrannosaurus rex, then I was like Blue, the little female Velociraptor from one of my favourite films, *Jurassic World*.

Taking into account what my dad had said, the next time my brother and I fought, and he used his fists, I hid under the study table, moving swiftly between the legs to block his attack, and I climbed on top of him and used my ruler to make my final blow.

The results – Blue 1: T Rex 0 (with blood).

Mum was horrified but Dad was impressed with the results. Over dinner, he made me promise not to use violence again, but he also bought me an ice cream that weekend for being resourceful and not accepting defeat because of my obvious size deficiency.

How does the desire to win show up in your life? Do you make decisions based on your chance of winning? What learning opportunities have you missed out on by not participating?

CHAPTER 7

Paper Swords

When I was at primary school in Hong Kong, my mum would brush my hair every morning, tie it neatly and make sure my school uniform was immaculately clean and ironed. Dressed in her old shabby clothes, she would walk me to school, revising my lessons with me as we walked.

I was always on time and I was polite and helpful to the teachers, school staff and wardens. Top of my class in every subject, I was also the school monitor every year, and if there was ever any kind of tournament, you could guarantee that I would win the award for my school. I was the perfect student.

Perhaps this didn't make me easy for other children to like. I was bullied a lot.

It started with jokes muttered behind my back, girls commenting on how terrible my mum looked, saying that she was dressed worse than their Filipina helpers at home. Then it became more obvious: laughing in front of me as I walked past, commenting on the hand-knitted jumpers that Mum had made, saying that we couldn't afford shop-bought jumpers. I didn't wear trendy, branded clothes and I didn't know the fancy labels. I was ignorant about pop singers, TV shows and celebrities.

With my parents being very strict, I never heard celebrity gossip or listened to the radio. My focus was on doing well at school, attending church and listening to my parents. I was constantly laughed at and called 'ignorant' because I didn't know about TV shows or popular music.

One term, a classmate challenged me to read Sir Arthur Conan Doyle's series of books about Sherlock Holmes. When I said I hadn't read them, she brought all twelve books to school the next day. It was only one month to the final exams. My mum picked me up from school, saw the huge bag of books and told me that this was a test. The books were meant to tempt me away from

my studies.

Every night after I went to bed, Mum would stay up in the kitchen and read the books. As we walked to school the next day, she would give me the synopsis, so I could pretend I had read them myself. My classmate would come by at recess and ask me where I was up to. I would tell her the plot and how much I was enjoying the books. This continued until Mum finished all twelve books and I returned them to my classmate. When the final exam results came out two months later, I came first in all my subjects. The classmate who had lent me the books came second. She cursed me to my face as I went to the podium for my award, and said, 'How could you? You read all my books. When did you have time to study?'

I went home that day with my award, but I was very sad. Mum had been right; it had been a test, and the girl had wanted to beat me by distracting me from my studies. I cried because her words really hurt. I felt I had no friends at school, and anyone who appeared to be my friend wanted either to copy my homework or to see me fail.

Mum told Dad about my tears, and he reminded me that words are like paper swords; they can't hurt me. Only weak people use words to attack the strong. 'Your classmates are just jealous of your academic success. Who will be laughing when you get a great job and become their boss, or their boss's boss?'

Mum brushed it off when I told her that my classmates thought she was my maid. I knew she was hurt by the comment but she gave me a defiant look and said, 'It doesn't matter what other people think or say. What matters is that you know who we are to you and that we would sacrifice everything for you.'

One of my key reflections on this incident is how my innocence, my naivety, was stolen. It changed the ease

with which I trusted people. I became a bit of a Sherlock Holmes, spotting incongruent signs in others' behaviour, and I stored this data in my memory to alert myself to deceitful behaviour or to traps designed to harm me.

Many years later, as I continued to excel at school, went to the top university in New Zealand and worked at prestigious firms, I would remember when times had been hard for us as a family. I would save up to make sure my parents were dressed in the finest quality garments – elegant and timeless outfits from Italy and France – ensuring they looked a million dollars, so that nobody would laugh at them again.

Have you ever been bullied by others for being too good at something? Have you ever felt that it's safer to keep quiet, act small and hide your skills in return for an easier life? Or did you learn ways to fight back against the naysayers? How can you begin to distance yourself from others' opinions that hold you back from shining bright as your true, authentic self?

CHAPTER 8

Expertise

'Knowledge is yours forever. Nobody can ever take it away from you,' Dad said. 'This is why we worked so hard to take you around the world, so you can learn from other cultures and their innovations, to experience their achievements, to understand how they live their lives and to learn from these experiences. Nobody can ever take it away from you.'

By the time we left for New Zealand in 1989, Dad had taken us to almost every country in South East Asia, on a three-week trip to Europe and on a tour of the West Coast of America. He also honoured his promise to my grandfather, his father-in-law, that he would take his daughter and his grandkids to see them every summer. I always looked forward to the summer holidays with my cousins. It was the closest I felt to being carefree, with no school and no homework. I could wake up late, have breakfast with my grandparents, go to the shops with them, play in the garden, eat the windfallen summer fruits and even get my clothes dirty.

If there was one place my dad talked about the most, it would have to be Switzerland. He loved Switzerland and thought of it as the land of the highest craftsmanship and quality of living. When he finally took us there to see the stunning Lake Lucerne and the Matterhorn, I was eleven. It was a dream come true for him and he bought us all the chocolate we could eat. He was very impressed with how such a small country had achieved so much: the finest watches, the Swiss army knife, the world-famous chocolates. He felt that worldwide acknowledgement for being the best in one area of craftsmanship was extraordinary enough, but to do the same with so many different products and in so many industries was exceptional. He encouraged me to learn from the Swiss, to find my own passions and to hone my crafts so that I too would be recognised as exceptional in my endeavours.

For me, this meant the art of Chinese calligraphy. My maternal grandfather was a calligrapher and some of my fondest memories are of sitting with him in his study as the sunlight flooded in. He would show me how to grind the ink stick on the ink stone, how to get the exact intensity of colour and how to write each character. I would slowly, carefully and repeatedly practise a character on thin rice paper, for hours until I could consistently replicate grandpa's original. Time would fly by as my cousins played in the garden, their laughter like background music, as I practised in grandpa's room upstairs. I was the only grandchild who was interested in learning this ancient craft, and I still find so much joy in handwriting thank you notes and decorating my journal with the skills I acquired when I was five years old.

When I graduated from the University of Auckland, my dad gave me a fountain pen from Montblanc. I have been using their instruments ever since, enjoying the art of writing with a pen crafted by experts. Many years later, I visited their museum in Hamburg and learnt that the final stage of creating the gold nib falls to an in-house specialist known as 'a nib grinder with a good ear', who sits in a completely soundproofed glass room. As the nib glides over the paper with invisible ink, they listen attentively to the sound it makes. Only nibs that do not scratch or snag and which generate a continuous sound pass the final inspection before leaving the factory. Now if that's not a real-life embodiment of quiet perseverance, I don't know what is! I was in awe and appreciated my writing instruments even more.

Dad had a very sweet tooth and a love of the finest things. He always said that you don't need to overindulge but you should always savour the moment. As I started to make more money and travel for work, I made a point of visiting the best chocolatier I could find to buy him

a beautiful box of dark chocolates. When he received the gift, he would scold me for wasting my money on him – and then go to the neighbours' houses and show them what I had brought back for him from my work trip. Mum said this was his way of showing how proud of me he was. I never saw him eat a whole box. He would carefully remove the ribbons and wrappings, look at the menu card, examine each piece and then pick one. He savoured every bite. Then he would carefully replace all the wrappings and put the box away until the next day.

He always said, 'Savour the moment. Quality deserves your attention and respect.'

What are your memories of travelling to other countries? Which qualities did you observe in other people and cultures, and how would you like to embody or reflect them?

CHAPTER 9

Standing Out, Standing Tall

There is a Chinese proverb – 大樹招風 It means 'A tall tree attracts the wind'. You might know this concept as Tall Poppy Syndrome. In Chinese, the concept comes from a classic novel called *Journey to the West*, commonly known as *Story of the Monkey King* – 《西游記》 這正是樹大招風風撼樹,人為名高名喪人。 Roughly translated, it means that if you occupy a high-status position, while you might have the power to influence and control, you also become a prominent target for others to attack. A tall tree is more easily damaged by a strong wind. Some might go as far as spreading false rumours to bring you down to earth.

When my dad was eleven, he was much taller than his peers and was often mistaken for being several years older. He loved playing basketball and was skilled at shooting hoops. With his charismatic laugh and his love of telling stories, he attracted a lot of attention in his village. He wanted to shoot hoops and win games at the interschool tournaments, but grandpa wanted another pair of hands to work on the farm.

In Happy Valley, we lived near a beautiful recreation ground at the Hong Kong Jockey Club. Dad would take us there to play football, keen for us to develop flexibility and to learn to strategise on the go as we played. But he was wary of any future success we might attain. He used to say, 'Don't stand out, don't be too predictable. If you become known as a talented player, you will get your shins kicked. What good would it be for the game, for the team, if you are carried off on a stretcher?'

I didn't appreciate the meaning behind Dad's words until I found out about his sporting past from Mum. Winning his place on the school basketball team, Dad became its secret weapon. Six months later, he was deliberately tripped by a player from the other team. Dad survived the fall, but his ankle became fragile, and he had

to rest for the next few games.

Later, while practising hoops in the school playground after school, he was attacked by a bunch of boys. They broke his already weakened ankle and he had to limp home in the dark. That was the end of his basketball dream. No one ever found out who those boys were, although rumour had it they were from another school's team and were jealous of his talent. But no matter, he was off the basketball team. Grandpa cancelled payment of his school fees, and Dad was back to working in the rice fields.

When I started winning table tennis matches at school, Dad was so worried for my safety that he insisted on picking me up after each training session and every game. When I became captain of the school team, he would wait for me outside the stadium, for the whole evening of games. You never know what the green monster can do, he would say. If you grow taller than the rest, someone will try to cut you down.

I was never physically attacked or harmed inside the stadium. Table tennis is not a contact sport. But I was insulted, bullied and verbally abused by opposing teams. Every time I heard such words, I would reflect on the proverb. If I was to stand taller than the rest, I would have to be willing to 'withstand the wind'. I would need to grow stronger, deeper roots to keep me steady and grounded. I would need to become more resilient and flexible to bend with the wind so that my branches didn't snap. And I would need to grow a nurturing canopy for the many others who also wanted to grow tall.

Learning resilience is a life-long practice. How resilient are you in the face of the comments and actions of others? Who represents a great example of resilience in your life? What behaviours or thinking

patterns do they demonstrate that you could start to emulate?

CHAPTER 10

Fairness

'The Academy Award for Best Picture goes to …'

We held our breaths.

'… *Driving Miss Daisy*.'

Our favourite film of 1989 had been *Dead Poets Society*. It didn't win.

'That's so unfair!' I cried. 'I've never heard of *Driving Miss Daisy*, so it can't have been such a box office hit! How could it win the Oscar?'

I remember Dad laughed at my disappointment and told me, 'Life is unfair. Do you see any Disney characters living next door? Do you really believe that a fairy godmother will come to save you like Cinderella and punish the person who did you wrong?'

I was sulking and ignoring his speech, but Dad continued: 'If I can turn a pumpkin into a grand carriage and rats into drivers, do you think I would still be doing three jobs? No one is coming to our rescue. You will have to be your own saviour one day.'

Just like his theory about never assuming your pay cheque will arrive each month, he was adamant that I should understand how lucky I was. I had both my parents, good health, free education, clean water and food – many other people were much less fortunate than me. He reminded me that good luck is not a given and that, whenever we can, we should help others in need. He also drummed into me that I couldn't expect others to treat me with the same high standards with which I would treat them. Just because I would never harm others, I couldn't assume that other people would follow the same principle.

'Always be vigilant,' he said. 'Don't expect others to play fair. Had I been more careful, I could have been a famous basketball player.'

Our only activities outside of school were at the local Roman Catholic church. Our family donated money on a regular basis, we went to mass every Sunday, my

parents were involved in various volunteer activities and my brother and I were in the church choir. I made many friends during choir practice. As I grew older, I became part of the Legion of Mary, helping local communities and rest homes, an experience that gave me a good start in understanding how fortunate I was.

On one occasion, one of Dad's friends from church borrowed a large sum of money from him and never paid it back. Dad just shook his head and said that the man had needed the money more than we did. He was confident that whatever we loaned to others, good fortune would come back to us in other ways.

The streets of Happy Valley were always clean and free of garbage, but I remember it was not like that in other parts of Hong Kong. At primary school, I would occasionally see the street cleaner in the evenings after my music lessons. I would smell him before I saw him. I remember making a face, and Dad told me off for being disrespectful. He said every profession is important for society to work harmoniously. The street cleaner was doing one of society's most important jobs. If nobody cleaned it, the whole street would smell, and rats would live in the rubbish. If I didn't work hard, I would end up with no home, and I would be forced to live on the streets with the rubbish. (Clearly, I thought lazy children were not so different from rats!) Without rubbish collectors, we would get diseases and people would die. I should be thankful that someone was doing such a great job keeping our streets clean. Listening to my dad, I realised that the street cleaner deserved my respect – and possibly an award.

Little did I know that, a few years later, for us to live in New Zealand my dad would have to work in a restaurant cleaning dishes and my mum would be a housekeeper, cleaning hotel rooms. I never looked at cleaners, workers

or rubbish collectors the same way again.

Sometimes life is unfair. How do you react to unfair situations? How could you handle them better? What can you do now to help others who might not have as many resources and privileges as you?

Part

2

Our New Home

CHAPTER 11

Creativity

One of my dad's greatest talents was the ability to think beyond what he saw. He would smile at me, point at his temple and say, 'You have to use this to think about all the possibilities you can't see right now.'

I guess he had to think that way. It was his way of surviving.

In 1984, when I was seven years old, Britain agreed to return Hong Kong to China. Immediately, Dad started researching migration and speaking to useful contacts. He wanted us to live in a Western country, not one not ruled by the People's Republic of China. I was ten when we visited our second cousin in Sydney and during our trip, Dad learnt about the unspoiled country of New Zealand. In 1989, shortly after the Tiananmen Square protests and massacre, Dad intensified his research and invested his entire life savings into a golf course in Rotorua, a tourist town about three hours south of Auckland. This investment was a crucial step towards residency in New Zealand via the Investor Visa.

On 2 January 1990, our whole family arrived in Auckland. Shortly after, Dad made the trip to Rotorua and discovered that there was no construction going on – the site was a wasteland, and all the images in the investment brochures were fake. He had lost his life savings as well as his retirement plan. When he returned from his visit, I remember wondering why my dad looked like he had aged ten years overnight.

Dad was fifty-five years old. His accountancy certificate from night school in Hong Kong was not recognised in New Zealand and he was not proficient in written and spoken English. He hadn't applied for any jobs in New Zealand because that hadn't been part of his plan. His intention had been to manage the golf course and meet lots of people that way. About a year before our move, Dad had shown me glossy brochures of beautifully

lush green fields and landscapes I had never seen before. Having never been to a golf course in my life, I didn't know anything about the sport. It wasn't usually on the evening news, and Hong Kong didn't have any driving ranges that eleven-year-old me had known about. I remembered seeing little poles with flags and smooth, manicured grass and sand bunkers that looked way better than any of the beaches in Hong Kong. How naïve of me.

Dad said he would be running this resort, and we would be helping him, during school holidays, to welcome the guests. I imagined myself running around the resort like in a scene from *The Sound of Music*, rolling down the sand dunes. The brochures showed images of the luxury apartments that were to be built next to the golf course, and Dad was so excited about the prospect of selling them as holiday homes to guests who loved golf, who would come to enjoy the course's facilities. He said we could even learn to play golf ourselves. It all sounded so amazing, and we couldn't help but share in his excitement about our new life in New Zealand.

But this, his retirement plan, had all but disappeared overnight like a dream, and all of his savings were stolen from him.

He couldn't go to the police and report the scammers. He was worried that even though he had been wronged, and had made his investment in good faith, if the authorities found out the whole thing was a scam, we might all have been deported. After all, we were on a migrant investment scheme. So, he kept quiet and used his creativity to find other ways to bring food to the table.

Anyone who knew my dad back in Hong Kong would say that David Liu was not a shy man.

With his broken English and his infectious laugh, he charmed everybody who met him with his warmth

and enthusiasm. With his investment dream in tatters, he started talking to everyone at the local supermarket, asking if they needed help. He would talk to people on the street near our house and ask if they had any work. The answer was always no, but he wouldn't give up; he would ask again the next day and the next.

Little did I know that we had a mortgage to pay and cash was running out.

One day, another migrant Chinese man spotted Dad and introduced himself as Tony. He asked if Dad would be interested in taking English lessons, part-time, at the local technical college. They wouldn't be expensive, and Dad would be able to meet lots of other migrants.

Dad – and Mum – signed up and began their courses at AIT (Auckland Institute of Technology). The classes were long and by the time they finished it was past 6 p.m. In Auckland in 1990, all the shops closed at 5 or 5.30 p.m. When my parents finished school, they were too late to get to a supermarket to buy food for dinner. For most of the students, their last meal would have been lunch, many hours earlier, and they would run to the school vending machine to buy Moro bars (a brand of chocolate bar), crisps or biscuits to sustain themselves.

This was not the kind of food that Dad wanted to feed us. So, he went on foot to a tiny Chinese grocery store about an hour away from the university and asked if he could sell the fruit and vegetables on behalf of the store owner. The owner agreed – but without offering my dad any salary. Dad would get a cut of whatever he managed to sell and then return with the little cart to collect more produce.

Summer 1990 saw the start of my parents' mobile 'Hello Fresh' concept. My parents would go to the store and collect a little cart of vegetables and colourful fruits based on what was fresh, in season and what Dad thought

would sell. They would then push the cart uphill to the AIT campus and sell food to their classmates at the mid-afternoon tea break. The students were now able to take dinner ingredients home to their families.

Based on the best sellers, Dad would then choose what to take the next day, even taking pre-orders. Mum would go to the local supermarket and buy a large bag of nuts and dried fruits, repackage them into smaller bags and sell them to classmates looking for a healthy snack during evening classes.

The students had no other options nearby – not even with a car – and, because every store shut before classes finished, demand was soon high enough for Dad to make the trip with the cart two or three times per day.

Dad's English didn't improve because he missed so many classes to build his business! But at least he soon had a small income to pay our bills during the school term.

However, the 'Hello Fresh' phrase didn't last long for my parents. It was our first winter in Auckland and we had no idea just how much it rained during those four months. The heavy rain usually came with strong gusty winds and the sky would turn dark by 4 p.m. Mum was already struggling to steady the small wooden cart, and with the weight of the fruit and vegetables, the task of pushing the cart uphill against the wind and the rain was almost impossible.

They persevered for as long as they could, selling fewer green vegetables and more root vegetables, such as potatoes, sweet potatoes, carrots and pumpkins, for winter stews. By 1992, the New Zealand government had loosened restrictions on trading hours, allowing corner shops and supermarkets to remain open till 9 p.m. My dad's business idea could no longer compete with the new competition. He would have to find another way to bring

home the bacon.

Thinking about your current objectives and challenges, how might you be more creative and resourceful to help you accomplish them?

CHAPTER 12

Discipline

The children of Asian immigrants usually have to cope with high parental expectations. Children are their parents' greatest assets. The main priority of Asian parents is that their children have a good life: one that's safe, secure, successful and, ideally, with a well-paid, highly respected job. Their first choice would be for you to become a doctor or a lawyer; at a pinch, maybe an accountant or an engineer might satisfy them. The problem was I didn't really fit neatly into those roles.

I couldn't be a lawyer because I had a rather stubborn moral code that saw everything in black and white, and I have always worn my heart on my sleeve. I have a terrible poker face. Dad told me that I would either make a terrible lawyer or I would make myself miserable by having to develop a split personality. He also said, with some affection, that I was too honest to be an accountant and wouldn't be much use unless I could be more 'creative' with my accounting rules. And because, in his eyes, only boys became engineers, I was left with one option – to become a doctor!

But that wasn't going to work either. I wasn't keen on the idea of cutting people open and I hated the sight of blood. I watched George Clooney in many episodes of *ER*, but I still couldn't convince myself to become a doctor. When the surgeon made the first incision, I tried so hard to keep watching, but I simply couldn't stomach such scenes. I thought I had let my dad down.

I will always remember his look of disappointment when I told him I had been accepted for a conjoint Bachelor of Commerce and Bachelor of Science degree. Even though the course required a higher qualifying university entrance exam score than the Bachelor of Medicine degree he'd wanted me to take.

I felt like a failure.

Six months before the university entrance exams, I

was preparing intensely for my scholarship exams when Dad sat me down for a serious discussion. He told me, 'If you go to medical school, I will pay your fees for the whole seven years. For anything else, you are on your own.' I was nearly seventeen years old and doing my best to save money. I had a part-time job working weekends as a sales assistant at Tie Rack. I was also tutoring other teenagers at school. I knew that these income streams were never going to come close to the amount of money I needed for my university studies. I had to find a way to earn more money, but I couldn't compromise on my ambition of achieving five A grades in my exams. Taking on more part-time jobs was not an option.

Having no alternatives, I took out a student loan and started working part-time with Dunn & Bradstreet as a data-entry operator. I was Pitman qualified and I was a fast and accurate typist with speeds of over seventy-five words per minute. I took another job as a market researcher for AC Nielsen, working on the phones, and I extended my private tutoring hours. Feeling too embarrassed to tell my university friends that I needed the money to pay for my student loan, I made up excuses about why I couldn't join them for social activities (especially those that cost a lot of money, like ski trips or weekends away).

I managed to repay the entire year's loan in full before the first academic year ended, while achieving straight As in all eight subjects that year. I then worked all summer long to earn enough to see me through the second year without having to take out another loan.

I wouldn't be human if I hadn't been a little bit jealous of my friends who had more money and who were living full and enjoyable student lives. They didn't have to lift a finger to pay for their tuition and living expenses, and their parents rewarded their good grades with new cars and skiing holidays. Every day after class,

they would go to cafés and karaoke bars, spending their allowances, while I had to work for every penny, as well as give my parents a share of what I earnt (this is expected in traditional Asian families).

While they had fun, I rushed from class to the tutoring room to pick up assignments to mark or to help at the student lab between lectures, just to make ten New Zealand dollars (around five US dollars) per hour! My evenings were never my own. If I wasn't studying, I was tutoring my private students. Then, once my tutoring work was done, I studied again from 10 p.m. through to the early hours of the morning.

My brother went to medical school after finishing his engineering degree, and I had always assumed he didn't have to pay his fees because he had followed Dad's wishes – but I was wrong! He also paid his way. Dad had told him that if he didn't get in the first time he applied, he wouldn't pay his fees.

Neither of us knew that Dad never actually had the money to put us through university, but when he told us that we hadn't met his standards, we never challenged his decision to withdraw his financial support.

My student days were filled with hard work and financial pressures, and I had a lot less fun than most. However, because of my extensive work experience throughout my four years at university, I was one of the few from my peer group who managed to find a job in the first year after graduating in Auckland. And this was at the peak of the 1997 financial crisis.

During my time at university, I discovered how to make the most of twenty-four hours, prioritising and juggling tasks like a pro, almost magically expanding my day to fit everything in. I trained my brain to be comfortable flipping between studying, tutoring and my multiple work commitments, university assignments, home life and even

a little bit of socialising. I became incredibly effective and efficient in brain hacking and streamlining my days. Did you know that the famous Greek philosopher Pythagoras made his pupils fast before lessons because he noticed it increased mental lucidity and physical strength? I discovered this accidentally when I didn't have time to eat. My mind was so clear and alert.

I created my own systems and structures for everything in my life, and I tracked and logged my mental alertness over several weeks. In doing so, I identified when I was most alert during the day, so I could use that time to focus on complex tasks and challenging new materials. I determined when I should exercise to re-energise my body, to get a second burst of productivity. I became aware of my own rhythms and how to make the most of my energy cycles. These lessons I have applied throughout my working life, and I doubt I'd have such skills if I hadn't had to stretch myself so much during four years of university in which I packed in the equivalent of six years of study.

I didn't have the typical student experience of drinking and partying – I couldn't afford the time or the money – but I did graduate top of my class with a first-class honours degree and no student debt.

My classmates would ask me how I managed to fit so much into every day. Did I have superpowers, or did I never sleep? Needs must, I thought to myself. I was very self-motivated and driven, and I had learnt to be highly efficient and disciplined to a degree that I might never have achieved if my dad had paid my fees.

What new habits or biohacks would you like to develop? How would you go about implementing them to improve your life?

CHAPTER 13

Blood Sweat and Tears

Wet mud and a strange salty, metallic taste in my mouth. A strong thump on my back, followed by another. I was flat on the ground, unable to move, not sure how I got there.

'Get up, get up. It's not about falling. It's about who gets up faster and recovers quicker.' Dad's voice echoed in my head. Am I dreaming? Is this real? Where am I?

I was never particularly good at sports. I learnt at a young age that I wasn't born with a sportswoman's body. I was shorter than most of my classmates in New Zealand, I couldn't run as fast and I didn't have their stamina. Rugby is New Zealand's national sport, but playing it with girls twice my size was never going to be a fair game.

During my secondary school years in New Zealand, my parents never came to any sports day or interschool match. They were too busy working at the hotel and restaurant. At least I spared them the embarrassment of seeing their daughter come last in every track race.

The one time I managed to catch the rugby ball, a girl from the opposite team kicked my leg and I fell over, face down. She then ran over my head to grab the ball. The umpire blew her whistle. I was lying on the ground, in the mud, my cut tongue bleeding into my mouth, unable to speak. Everyone thought I had a concussion, but eventually I got up and, with Dad's words in my head, I continued the game.

'Stop crying! She doesn't deserve your tears. Why are you wasting your time feeling sorry for yourself? I told you that you can't trust others to do the right thing just because you do. Now pick yourself up. It's OK to fall but get up quickly. No more tears! That helps no one. GET UP NOW! Dust yourself off, hold your head high and tell me what you can learn from this?'

I didn't get the ball back, but I played hard and stayed on the pitch right to the final whistle.

As Mum rubbed Deep Heat into my aching muscles and tended to my bruises, she tried to soothe my pain. By contrast, Dad told me to grow a shield and to stop behaving like my soft-spined mum who trusted others too easily. 'Have you learnt nothing?' he asked.

I was sulking and said I hated those bigger girls who'd run over my head. Nobody had helped me up. I told him that I hated rugby, and I hated New Zealand.

Dad was having none of it and told me to stop sulking, to stop wasting energy on feeling sorry for myself. He told me it was time to find my strengths and play to them, time to stop trying so hard to be something I was not. 'You have to do what's right but don't expect others to be honourable. Getting kicked is nothing. It's your fault you didn't see her coming!' he said.

I realised I couldn't beat these larger girls by playing their way, so I started watching other games that might suit me better than rugby. I tried out for the school's cricket team. I have an unusually hyper-flexible wrist and small joints. Together these gave me the tools required for killer spin bowling.

I practised and practised my bowling aim and control. I knew I couldn't run as far, or for as long, as the other girls, but I could sprint between the wickets, and I was calm, steady and consistent with my catch. By the time I was sixteen, I had become my school's top spin bowler. In most matches I didn't even have to run. I simply bowled the opposition out. They never saw me coming.

A wide body of research has highlighted the importance of focusing on harnessing your strengths and finding areas where they are valued; for example, CliftonStrengths Finder focuses on investing in your strengths and building your career around them.

If you would like to find out more about your top strengths, as well as how you can develop your talents into strengths to empower those around you, you can find more information from Gallup and take their CliftonStrengths Talent Assessment.

CHAPTER 14

The Power of Visualisation

Long before Rhonda Byrne's *The Secret* made the New York Times bestseller list and caught Oprah Winfrey's eye, my dad was already a pioneer of positive affirmation and visualisation.

We were taught to always wish him a successful and lucky day when he left the house for work in the morning, and he would tell us to visualise the sort of school day we wanted to have while we packed our school bags the night before.

When I hurt myself and needed to apply ointment, he would repeat positive statements that meant 'powerful miraculous medicine, you will heal very quickly', and he would keep repeating it like a mantra until the ointment had sunk into my skin.

As a little girl, I was a big worrier. I would worry about things my classmates might say to me or about not getting full marks in my tests and exams or that the only chapter I hadn't fully memorised would be the one in the test, and so on. I probably would have worried if I had nothing to worry about! But Dad would point out that this was no way to live my life: 'If you think about bad things, then bad things are more likely to happen. Focus on what you want to see, the results you want to achieve.'

When I started losing matches at table tennis, he would tell me that my body language showed that I had given up and accepted defeat before the game had even started. He told me that I needed to focus on winning the next point and the next point until I'd won the game. I had to stop catastrophising all the time.

I don't know where he learnt this approach, but I remember that whenever something terrible happened on the news he would say, 'That's happening to other people. It won't happen to us. Do you know how incredibly lucky you are? Count your blessings. You have both your parents and you live in a safe, warm house in a

nice neighbourhood. When I was your age, I was already working at the docks, living in the attic of the factory. I have not seen your grandparents since I left China.'

I can't imagine having to say goodbye to my parents at the age of thirteen, knowing I might never see them again. In the 1940s, he couldn't just take the train back to China for a visit. He left them in the full knowledge that he might never be able to see them again. He couldn't call his parents because they didn't have a phone. Now, I can FaceTime my mum whenever and wherever I want.

I remember coming home really upset from school one day. My classmate had tricked me into showing her my laboratory results, and she then copied my numbers without telling me. She said that she had just wanted to check that her results were in the same ballpark. I trusted her and didn't think anything of it. A few hours later, we were both called into the teacher's office and given a FAIL for that assignment. The science teacher said we must have cheated. She didn't care or listen to my pleas; she just said that if I was stupid enough to share my work, then this would be my lesson. As our punishment, we both had to repeat the entire experiment after school and rewrite our reports. I was ashamed and angry and felt so stupid.

Dad looked at me, told me to stop crying and said I needed to grow a backbone. I needed to imagine that I was a warrior with a sword and a shield. When anybody attacked, I should imagine this shield immediately appearing to protect me from all incoming attacks. I shouldn't put down my shield until someone had proven to me that they were worthy of my trust. He told me I didn't always need to attack to win, that I could be an exceptional goalkeeper, deflecting all attacks, and still win the match.

Do you use positive affirmations or visualisation to reframe and change your outlook? If you want to know more about the science behind positive psychology, Part 4 of this book provides a list of resources.

CHAPTER 15

Being Invisible

My parents were never the same after they had to take work cleaning hotels and dishwashing in Auckland. They weren't treated with respect by their bosses or the hotel patrons. They would come home exhausted and would refuse to be seen with me in public for fear of someone recognising them as the cleaners at the hotel and restaurant. My dad's leonine pride seemed to disappear overnight, and he shrank into a little street cat that had been kicked around.

Dad told me not to acknowledge him if I ever saw him on the street. We stopped going out together, even to the supermarket to get groceries. He would tell me that he wanted me to stay home and study. He would go to mass during the daytime, while I was at school, and we stopped going to church as a family on Sundays. It was as though I was walking down our high street followed by my parents with the shame bell of Septa Unella (*Game of Thrones*) tolling behind them, humiliating them wherever they went.

It was another eight years, when my brother and I both had full-time jobs and were paying for all the household bills, before my parents were able to retire. It was another ten years before they were willing to be seen out and about with us.

My parents didn't even attend my university graduation ceremony for fear of causing me shame. In fact, I didn't have another photo taken with my dad until I moved to the UK.

My dad had taught me to always treat others with respect and kindness because you didn't know their story. Sadly, he wasn't able to judge himself and my mum by the same standards. My dad was a very proud man, but circumstances had changed him.

This is the first time I have written this down, and tears have soaked the lined paper. I hadn't realised how

much I had pushed down this pain and now my body can no longer contain the sadness. It's as if I have defrosted part of me that was trapped in carbonite (like Hans Solo in *Star Wars: Episode V – The Empire Strikes Back*).

I told myself that I must never let my parents down, that after all their sacrifices there was nothing I could do to ever repay them. This, of course, placed huge emotional pressure on my shoulders and compacted my already super-critical mind. How could I possibly add to my parents' burden? How could I even consider opposing any of their instructions or ideas? How could I bring anything but glory home?

Many years later, in 2012, I had one of the best holidays ever with my parents. I treated them to business-class tickets from New Zealand to London via Hong Kong. I booked them with Cathay Pacific so I could be certain they would be looked after by Cantonese-speaking cabin crew, to make them feel more at ease.

We then went on a three-week tour around Portugal, starting on the Algarve in the south, travelling up the Atlantic coastline and ending in Porto, with inland stops on the way to visit the shrine at Fatima. I researched restaurants meticulously, making sure there would be plenty of fresh seafood, and included a few Michelin-starred restaurants. I had never seen my dad eat so much or laugh so loud. He was proud to be travelling with me and to be seen with me. He was so relaxed and curious. At times I felt like I was the adult, following him as he ran off checking out shops and monuments ahead of me. He was always asking questions, smiling and greeting the locals and thanking them for their hospitality in restaurants, coffee shops, cake shops, souvenir shops or wherever we went.

We were there during the UEFA European Football Championship and the Portuguese team was doing very

well. He would watch games with the locals in the bars, enjoying a small beer and cheering on the teams. Even though he didn't speak a word of Portuguese, he blended in like a local supporter.

In a country where no one knew who he was or what he had done to provide for his family, my dad could finally walk proudly around the cities with me, smiling and telling the restaurant staff, 'This is my daughter. She brought me here to watch the football matches and enjoy Portuguese food.'

I have spent the last six years studying neuroscience, polyvagal theory (how the vagus nerve relates to health and behaviour) and Internal Family Systems (IFS). IFS is also known as parts therapy and posits that our mind is made up of multiple parts. These parts are largely unconscious and they can play healthy or extreme roles. IFS divides these parts into three types – Managers, Exiles and Firefighters – in terms of how our bodies respond to trauma.

I now realise that I unconsciously associated being visible with danger: if I'm seen to be doing well, I will be torn down; if I appear financially successful, my home will be burgled and my loved ones harmed. Showing up to support those who suffer feels dangerous, but blending in and staying small keeps my nervous system feeling safe.

After working with my own nervous system through somatic work, reconnecting with my body, learning how to identify and manage my triggers before my fight or flight (sympathetic) responses kick in, I realised that my protective parts still believed that I was a little girl unable to defend myself. So now I practise regularly, befriending and speaking to my parts and learning how to self-regulate, co-regulate with others and live in a blended state.

My new life as an entrepreneur and female founder is full of challenges and unknowns. My brain interprets

these as unsafe and threatening, but uncertainty does not necessarily equal danger. I can be excited about the opportunities and challenges ahead without shutting down or running away. I can remain in parasympathetic mode (accessing the network of nerves that relaxes my body after periods of stress or danger: a counterbalance to fight of flight). If you want to learn more about your nervous system, and how it affects your life, there are additional resources at the back of this book.

QUIET PERSEVERANCE

CHAPTER 16

Observe and Share Your Knowledge

When I was fifteen – before I started tutoring – I had a part-time job at Woolworths, the local supermarket. Some people think retail work is dull or uninteresting, but I used to set myself challenges to see how quickly I could bag all the groceries into the fewest plastic bags. I would visualise the space each item would need and work out the best way to pack the shopping, so that any sharp edges wouldn't tear the bags. It was like playing 3D Tetris but with far more, really weird, shapes – and better than having my own Game Boy.

Towards the end of the day, when the red sticker promotion items became available, I would rush around the store collecting ingredients for dinner that night, finding the best of the Reduced to Clear items, like a fifty-cent bag of lettuce, a fifty-cent bag of bread rolls or a one-dollar portion of meat that was due to expire that day. I would then head home and wait for my parents to create whatever they could with what I had bought. Often, our family dinners cost less than five dollars. I learnt not to complain about the food and instead to appreciate the creativity my parents showed in delivering enough protein, carbohydrates and fibre for our everyday needs.

To this day, this behaviour is deeply ingrained in me, and I still look at the contents of my fridge and conjure up dishes based on what I have, so that nothing goes to waste. I don't always get it right but sometimes I discover new creations.

Around the same time, I noticed that some of my classmates at Epsom Girls' Grammar School were struggling with mathematics. Maths came easy to me and very quickly I attracted a small group of classmates who would ask to sit with me at recess, so I could show them how I solved our maths problems so rapidly.

My entourage started to grow and as the questions

became more difficult, the answers took longer to explain and work through. Soon, recess was too short for me to help everyone, so I began offering tutoring after school. At first, I did it for tuck-shop money, to buy Cookie Time biscuits (still one of my favourite things!), but this evolved into my receiving actual fees from parents who asked me to privately tutor their children at my house. The dining room at home was renamed the Tutoring Room, and I would teach till 10 p.m. three nights a week.

Many of my 'students' got into their top-choice university and went on to have very successful careers. To this day, I am still in touch with many of them. I feel incredibly privileged to have been part of their learning journey and to have been able to support them when they struggled in large classrooms. I became their mentor, their friend and a kind of big sister. I helped them with many of their social challenges in class, and with friends and family.

Looking back, I didn't realise how much tutoring would impact how I coach, mentor and support my teammates, my colleagues and my direct reports today. I have always loved to learn and to share things I find useful; it comes very naturally to me. It's no wonder that coaching and training are my two most frequently cited strengths when staff give me their 360-degree feedback.

My time spent at AC Nielsen as a telephone researcher during my university years was both difficult and extremely useful. Being an introvert, I was pushed out of my comfort zone, and it forced me to learn how to make small talk with random strangers. However, I also learnt to listen and to hone my questioning skills. I even took ideas to my supervisor on how some of the questions could be better phrased or sequenced to get the information the client wanted. As I worked with more and more of the different questionnaires we used, I became

skilled in the art of questioning. This was of great help to me during the final year of my Bachelor of Commerce and Bachelor of Science studies because I was able to combine advanced market-research methodologies and advanced experimental designs with my own real-life experiences.

Who would have known that the part-time job I took at seventeen would be so useful?

CHAPTER 17

Pivot, Pivot, Pivot

My first real job after graduation was not a glamorous one. Some of my friends from the science department went on to further education, pursuing master's degrees, and a few of them became researchers and analysts at consultancy firms. Most of my friends on the commerce side, who majored in accounting and finance, went straight into one of the big four accountancy firms in Hong Kong as auditors.

The problem I faced was that recruiters didn't understand my qualifications. While I had studied for breadth and diversity of learning, I did not have a standard degree that made sense to recruiters who wanted to put candidates into neat little boxes. It had made complete sense to me to combine my passion for science and genetic research, and for statistics and market analysis, with the management of organisations and people. Unfortunately, that didn't make sense to most of the graduate training programmes out there. Even having achieved the top results in my academic year, and with a scholarship, I didn't have a job waiting for me when I finished my final exams in December 1998.

In January 1999, I decided to travel to London to see my best friend from secondary school in Hong Kong, who was then completing her final year at the London School of Economics. I was a guest in her dormitory for one pound per night. There was a time limit on how long guests could stay, so she had to keep rotating me around different friends so I that could be signed in, but, eventually, the doorman just let me through. I spent a month in London during the darkest, wettest, gloomiest time of the year – and I loved every minute of it. I was in awe of the history, the opportunities and the sheer scale of everything I saw. I promised myself that one day, when I had acquired enough skills, I would come back, to learn and live in this vibrant city of possibilities.

After my month in London, I returned to Auckland. I still had no job. One day, I went with Mum to pick up her Nu Skin vitamins order. As we waited, I noticed how badly the receptionist was struggling with taking orders on the phone while customers waited to be served. Once the angry clients had left, I asked her if she used any methods to help her remember the product codes, so she wouldn't have to look up every single one on the system. She said that she had tried but she kept getting them wrong. I asked her if some products were ordered more frequently than others. She said yes, that there were five top sellers that almost everyone bought. I borrowed a pen and a piece of paper and asked her what they were, along with their respective codes. Giving her the piece of paper, I told her to stick it next to her computer screen, so that she would only need to look up the other products, not the best sellers.

Two weeks later, we returned to Nu Skin to get some more vitamins for Mum's friends. The receptionist was so happy to see me. She said I had saved her so much time and frustration – waiting times were much shorter, and her boss was so happy with her improvement that she was going to get a promotion. She asked if I would be interested in her job.

I felt torn. On the one hand, any job was better than no job, better than sitting at home typing up cover letters and waiting for time to pass when I could be earning money and gaining work experience. On the other hand, I felt ashamed and embarrassed. How could I, a top graduate from Auckland University who had graduated with a scholarship, work as a receptionist? I could have skipped four years of university and worked as a receptionist without a degree. What was I going to tell my friends?

That evening, when Dad finally got home from

work exhausted, I told him my news. He said, 'I would have loved for you to work for one of the big names on the FTSE 100 and be a CEO, but you must get in the ring to have a chance of winning the game. Staring at the match on the outside is a waste of time. You must start somewhere and be humble, learn from your colleagues and your seniors. Work hard and learn. You can only move up from here, and as you gain more experience, one day you will be ready for the big fight.'

So, I became a receptionist and order taker for Nu Skin. It was a fun few months. Everyone there was lovely and friendly. It was a nurturing environment for this introvert to step into and face clients all day long, completely out of her comfort zone. I gained knowledge about network marketing, product development, healthcare and skincare, and, most of all, it planted the seeds of my fascination with operational excellence. Of course, I didn't know it was called that at the time. I just loved improving every process that crossed my path.

Even today, I question every process to make it better – is there a way to make it more streamlined, more efficient, to reduce the handoffs and errors? At Nu Skin, I would watch the packers in the warehouse during my lunchbreak and I would ask them what the most annoying part of their job was. I would ask the order takers what drove them crazy. In my client-facing role, my confidence grew and I would ask the top-selling members what they would like to see changed. Using their feedback, I redesigned processes for order taking, streamlined ways to reduce time between taking the order and packing it and I worked on how to reduce errors and waste. This eventually led to the start of my journey as a Lean Six Sigma Black Belt process engineer.

Sometimes it's difficult to see what lies beyond the clouds in your way. I am so grateful that Dad encouraged

me to play the long game. Achieving your greatest ambition can be a long, winding road with many challenges and obstacles, but the key thing is to start. Trust that what you desire is there for you, and that you have within you all that you need – the courage, the ability and the grit – to get there. Action breeds clarity. Like Indiana Jones in *The Last Crusade*, you need to take a leap of faith for the path to appear. Don't wait for the perfect moment to begin – it might never come. In one of my favourite episodes of *Friends*, 'The One with the Cop', Ross struggles to carry his new couch up a narrow stairwell. But the path we think is the obvious route doesn't always pan out. Like Ross, we must *pivot* and be open to experimentation, to different ways of moving forwards.

What assumptions have you made about your various options in a tricky situation (for example, staying in your current job or taking a leap of faith to change tracks)? How can you test your assumptions and challenge yourself to view the situation from different perspectives?

CHAPTER 18

The Art of War

One of the few forms of entertainment I enjoyed with my parents when we lived in New Zealand was watching sport on television. Tennis, basketball, cricket, rugby and the Olympic Games – we watched them all. Dad would check to see that we had finished our studies and then we'd join him to watch a bit of telly after work.

He would narrate and comment on the styles of players while teaching us how to play to win.

'See that serve? Do not show your full strength. Reserve some of your power moves! Everyone thinks it is over, but it's only over when you decide it's over.'

The advice kept coming: 'Keep calm, control your emotions. Look at how Roger Federer plays. Now, look at Marat Safin. Did you see that? Manage your temper. No one respects a sore loser. Today you have lost, but tomorrow you will return to practise and you may win at the next tournament.'

I have always admired Federer's sportsmanship, even though I can't hit a tennis ball to save my life. I love watching him play: his calm and professional demeanour on and off court, always composed and level-headed and, most of all, always gracious in both victory and defeat. I like to think I have tried to model his professionalism.

Life is like a professional game. Play gracefully and professionally. There should be no outbursts during games. It is never OK to lash out at your opponent or the umpire, regardless of the circumstances. Tennis is a mind game, and it needs focus and strategy. When you are raging, you can't react quickly and accurately.

Dad's sports observations were not just about making us better at sport. He wanted to make us better at business too.

He always encouraged us to have side gigs, to keep looking out for opportunities to learn and complement our skills, especially if they brought in extra income. Just

because we were good at something, we shouldn't get too comfortable. See how quickly each tennis champion is displaced by the next up-and-coming star. We shouldn't stand still because a younger, brighter, faster opponent will always come along and try to take our place.

If we were not evolving and growing, he told us, we would be left behind. We needed to search out and develop complementary skills that would help us with our careers in five or ten years' time. What skills could we learn which would soon be in demand?

Right up until the day he was suddenly summoned to heaven, Dad would read the newspaper every day to stay informed of what was going on in the world. He always said, 'You cannot position yourself if you don't know where you stand in the world. There are so many amazing reporters bringing you news and intelligence from every corner of the world. It is even better than having your own team of spies.'

Dad's boss needed an accountant for his business. The accountant would come in for a few days and make a lot of money doing things that didn't look that difficult to Dad. Dad thought it was a good skill to have and started investigating how he could take advantage of such opportunities. He never told his boss he was doing his accountancy qualifications at night school, even after he'd finished the course. With his new qualifications under his belt, Dad started getting side jobs to supplement his day job. He never mixed up the two roles, keeping his day job and his side hustle separate. He knew that if his boss found out about his new skills, he would expect him to do his accounts for free.

Eventually, the side hustle allowed him to buy his first Rolex watch. He referred to this as the time when he finally made it – he owned a watch made for greatness. He then met a property developer who presented him with

the option to buy an apartment off-plan (before it was built) at a heavily discounted price in Happy Valley. My parents owned their own apartment years before Dad's boss bought his own first home.

How can you keep yourself informed about future trends, so you can ride the next wave instead of falling behind?

CHAPTER 19

Reinvention

Soon after the fun times at Nu Skin began, I saw a job in the local newspaper for a trade analyst position at Sealord, New Zealand's largest fishing company. I loved their seafood, so I applied for the job even though I had zero experience in fast-moving consumer goods (FMCG). But I knew that, with my interest in analytics, my curiosity, tenacity and patience, I could quickly learn anything I set my mind to.

Before the interview, I was so nervous that I went to the bathroom six times! My future boss asked me why I thought I was the best person for this job when I knew nothing about FMCG. I told him I loved numbers and solving problems, and if he was willing to give me a chance, I would work really hard and do my utmost to learn about the industry and the best practices to support his team and the business. He later told me he liked my attitude and that's why he decided to take a risk and offer me the role.

The position at Sealord was a newly created one in which I was expected to analyse the sales data collected by AC Nielsen from each supermarket chain across the whole of New Zealand. I would then provide insights into promotional sensitivity, and variations across chains and locations, and feed this information to the logistics department. This would help them predict the volumes of each product required for the next twelve months, so they could reduce unnecessary inventory and focus their marketing efforts.

I was eager and wanted to look at every single way of dissecting the data: how they could help with future promotions, whether any particular products were underperforming in a particular chain or location and how to best support the local sales manager. I also wanted to look at space management, meaning where the product was placed on the shelf and how that impacted

our sales. I spent time with the logistics manager to see what data helped him predict future needs, and I was also excited to see what new products were being created to supplement the existing best sellers and to tap into new market segments.

It was a fascinating job for a data geek like me. I was mining every bit of data I could get my hands on and using the AC Nielsen tool to the max. I would test little theories of mine with smaller stores and then eagerly wait for the data to drop the next month, to see if my hypotheses were correct.

I loved visiting the stores and seeing the promotional displays at the end of the aisles in various supermarket chains. I loved being on the road and spending time with the regional sales reps, to understand how they worked, so I could design and customise supporting marketing materials in a format that worked for them. It was so much fun to see how the data translated into real life. I hadn't known just how much science went into running each store. I have always loved grocery shopping, but this was like being Neo in *The Matrix* – I could see so much more than the merchandise on the shelves!

I remembered working long into the night and my dad waiting outside in the car park to pick me up at 11 p.m. I would not stop working on my presentation deck until I was 100% happy with it. Dad would never grumble. He'd tell me, 'It's ok, we can reheat your dinner. When you get a job, do it well, or you might never get the opportunity to change their perceptions again.'

My long hours and perfectionist work ethic soon became known to the rest of the firm. After collaborating tirelessly with many supermarket chains over eighteen months to create stronger sales, the largest supermarket chain in New Zealand recognised us with their Best Supplier Award and as their Partner For Growth in the

canned seafood sector. I couldn't have been prouder of my contribution.

But there was a dark side to my obsession with data mining. It meant I could never cover all the different permutations. I made it impossible for anyone to help me as I obsessed over how to get the model to the nearest decimal place. I would fuss over every single detail in my presentation pack, from font size to alignment, to equal spacing – details that were neither appreciated nor important to the clients or my superior. But it would upset me if I saw an extra space or if the printer's offset was not aligned. I felt like a failure when my sales predictions were slightly off or if a promotional lift hadn't occurred as I'd predicted. I would beat myself up for weeks. Little did I know how silly this was. I will never forget the day one of the senior managers took me aside after finding out I had done another all-nighter at the office and said, 'Victoria, 80% is good enough. The time you spend on the last 20% is not going to yield the benefits you think you will get. Don't kill yourself. One day you won't be able to physically cover all the bases, even if you don't sleep! So, focus on what matters – the 80%. Prioritise that. And then go home.'

Being an introvert, I often struggle to speak up at the opportune moment. Earlier in my career, I would find it hard to structure the right sentence to present my thoughts impactfully, or I would stumble at the key moment and lose the attention of my audience. I cannot tell you how many opportunities I have missed! To make matters worse, I used to have a self-limiting belief that speaking up in a meeting when I hadn't been asked to do so was rude and vulgar.

After witnessing multiple extroverted colleagues getting promoted ahead of me, I realised I had to change. I stopped expecting my manager to recognise my

strengths and achievements, and I started building cases and examples of my value add and practised presenting them to my empathetic friends. Eventually, with lots of practice (and coffee and cake which I would bribe my friends with) I started to get more confident in expressing my ideas in a succinct and impactful way. Although I still get nervous in a public setting or at important board meetings, I now know how to manage my anxiety and reframe my nervousness as an eagerness to share my opinion when it counts.

Many of my clients share their frustration and resentment when their more extroverted colleagues get more opportunities. What can you do to reframe your perception that speaking up is a form of vulgar bragging? How can you improve your communication and presentation skills? Who can support you to build your confidence so you can express your thoughts with a wider audience?

CHAPTER 20

There Is No Vice. It's About Building Your Tolerance

Watching the news on television with my dad, I was always confused to hear about society's problems with alcohol abuse, drug addiction or gambling. These were concepts I couldn't get my head around. I remember asking Mum why we had never rebelled and tried these forbidden pursuits. She told me that Dad would have disowned us.

At the time I didn't realise how much I had been programmed throughout my childhood to be obedient and follow my parents' wishes. Dad never had to tell me not to drink or smoke, but he did tell me lots of stories about such things. As an adult, I now know they were fictional but as a seven-year-old I believed the stories my dad told me and I never challenged their veracity.

He told me about Peter's daughter, who tried drugs, got kicked out of school, became a prostitute and then died of an overdose. She broke Peter's heart and brought shame on her family. Michael's son became a member of a gang and started drinking a lot; he then left home and died. Paul's daughter ran up major gambling debts and they had to sell their house; it broke Paul's heart. I know now that these stories weren't real, but they really scared me then.

The idea of bringing shame on the family and breaking my dad's heart was unthinkable. No wonder I never contemplated trying anything bad or forbidden.

At university, some of my friends would invite me to their house for karaoke or a BBQ and usually the boys would be drinking beer. I asked Dad, 'Why do people drink? What's the purpose? What would happen if I tried it? Would I become a different person? Would the worst version of me come out if I had alcohol – like when the gremlins are fed after dark in the film?'

He then took a bottle of Stella Artois from the fridge and opened it in front of me and said, 'If you want to know what it's like, then please try it at home. You

don't know how your body will react or what your limits might be. It's safer not to test yourself at a friend's house, where someone might take advantage of you. Now drink this.' Dad held out the bottle.

It tasted horrible. I absolutely hated it. I choked and I coughed, and the bubbles went up my nose. I couldn't understand how my friends could drink multiple bottles of this when I couldn't even finish a third of a bottle and then fell asleep right after.

Dad said that, in the business world, you either learn to drink better than your clients or you simply don't drink at all. You need to know your limit. Given how much I disliked it, at the age of eighteen I decided to be a teetotaller, and I've stuck to this vow throughout my working life. It hasn't always been easy to handle the continuous questioning from my colleagues – 'Is it your religion?' – or the social pressure to conform and the social pitfalls of resisting.

The world of financial services was all about socialising with colleagues and clients, indulging in happy hour drinks and celebrating the big deals. Everything seems to revolve around alcohol and if you don't, or won't, drink, you risk not being invited to events or being excluded from the inner circle.

There's a lot less smoking these days than when I first started working. Back then, if you didn't smoke, you couldn't hang out with the smokers and learn all the company gossip. And if you didn't party, you had a much greater challenge forming the social bonds you needed with bosses and colleagues. I felt I didn't belong to any of these groups, but I couldn't bring myself to try. The photographs of blackened lungs on the cigarette packets were enough to put me off completely, and the smell of smoke was awful. When I was teased by my school friends for not trying to smoke, I simply stopped being

friends with them.

Dad said it was a choice I needed to make. He never smoked, but he did drink whisky. In Asia, whisky is a symbol of success and it's very popular in business settings. He was experienced at posing – making it look like he was drinking when he wasn't. He also learnt to handle the effects of the liquor so he wouldn't be conned during a business negotiation.

These days, I enjoy the occasional sip of champagne or wine with trusted friends in a social setting – but never in a business environment. I enjoy a mocktail and the knowledge of self-control better than any alcohol. Just like my mum, I have a terribly low tolerance: one sip and I am asleep. Alcohol, for me, is even more effective than sleeping pills!

Have you been pressured to do things in and around work that conflict with your social identity and values? Did you make yourself fit in to avoid being left out?

Part

3

Leaving the Nest

CHAPTER 21

Companionship

I went to single-sex schools from the age of three right through to seventeen. As you can imagine, my social interaction with boys was very limited. I only interacted with a few of my brother's school friends, with church volunteers at the weekends and with my cousins during summer vacations.

When we first moved to New Zealand, I was very self-conscious about my limited vocabulary and I was not at all confident speaking English. Given that I was an introvert by nature, I barely spoke at school and struggled to make friends.

In my second year at high school, around the age of fourteen, they announced that there was going to be a school social. I was terrified and I really didn't want to go, but every student was strongly encouraged to attend. I asked my teacher if I could be excused if I had a note from my parents. She was shocked and asked me why I wouldn't want to go and have fun – everyone would be there, and all the neighbouring boys' schools had been invited. I couldn't think of anything worse.

Everyone in my class was talking about what they were going to wear, but I just wanted to dig a hole and hide. A week before the school social, Dad told me stories about the girls who had chased him at school or at the basketball club. He told me not to be like those girls, who were far too keen. He said boys liked a challenge and were not interested in girls who chased them. He had avoided those types of girls and spent seven years courting my mum, who was independent, capable, successful and much more of a challenge.

One of the girls who saw my dad as husband material had a wealthy father. He owned a local factory and offered it as part of her dowry. Dad politely declined and said he would like to make his own way in the world. The girl was 'nice enough', he said, but he didn't want to

be treated like a hostage or part of a business transaction. He worried that if there was something she didn't like after they had married, she would always be able to throw the factory back at him and criticise him, saying that he'd only got to run the factory because of her dad.

He would have never admitted it, but I can't help thinking he had a chip on his shoulder because he had received nothing from his parents and had no valuable family connections to offer his future partner or her family. He wanted someone who would understand his background and who preferably came from nothing, just like he had. He said it was important to him that Mum appreciated how hard he worked, and that money didn't just land in his lap.

There is a Chinese saying about finding a partner from a similar background and culture: 'A wooden house matches wooden doors; a bamboo house matches bamboo doors.'

Dad always said, 'Find someone with a similar upbringing and family beliefs. There will be many challenges in your life, and you'll handle them better with a companion by your side who has similar beliefs and values. Find boys from simple, happy, complete families. You don't know what issues they might have if their parents are separated or divorced.'

I knew Dad was very conservative and protective in this regard. His black and white view of the world may not be applicable nowadays, but his intention was for me to consider someone's family system – whether they had good role models at home and understood the value of working through the challenges that affect every relationship. He wanted me to find someone who was self-aware and who had done inner work to overcome any family history or trauma that might affect their adult selves.

On the evening of the social, I sat with my classmates, who were all dressed up and wearing make-up. As the evening progressed, more and more of them left the bench as they were asked to dance, leaving me more and more anxious. When a tall Chinese boy came over, I immediately ran to the bathroom to hide.

I waited for what felt like forever and when I came out again, he was still standing in the same spot, close to where I'd been sitting. I tried to hide but he spotted me, came over and asked if I was OK. He said that if I didn't want to dance, we could just sit. 'No, thank you,' I said and suggested that he please ask someone else. Respecting my wishes, he left, leaving me sitting on the long bench inside the auditorium all on my own, watching everyone dance beneath the disco lights, wondering if they were bamboo houses or wooden houses. How could I tell them apart?

After the school social, Dad started to share more of his thoughts about companionship with me. He never used words like love, marriage or dating. He simply said I needed to make careful choices about who to spend my time with.

The principle of matching doors and houses applies across many aspects of finding a partner.

Dad told me I wasn't born with outer beauty, so I should focus on cultivating my inner beauty. If I could learn to be independent and intelligent, with a vast array of interests, those qualities would be mine forever and would not fade over time, unlike youth and beauty. One of his favourite sayings was 'Good looks won't put food on the table.' Clearly, he didn't know about Tom Cruise!

Dad warned me to be careful and to choose wisely. He said girls were like precious bottles of wine – once the cork is out, the wine spoils and you can't just put the cork back in again. He wanted me to be the valuable bottle, safe behind closed doors, and not the bottle that had been

opened for a quick drink, which was then unsellable. If he could have put me in a chastity belt, I think he might have done!

Armed with all his advice, and wine-based metaphors, I set out to make my own mistakes.

There was a boy with cute dimples at a neighbouring boys' school who also played table tennis. I used to see him every few weeks and, as an immature sixteen-year-old, I thought I was in love. When Dad picked me up from the stadium, I told him that I thought this boy was cute. Dad said, 'Let's see what is on the inside.'

I would regularly give the boy my study notes. I'm not sure if that was my idea of flirting, but it was the only tool in my toolkit. One day I delivered my notes, walked away and then realised I had forgotten to tell him something important about the chapter I had not yet summarised. As I quietly walked back towards him and his friends, I overheard him talking about me and laughing with them.

I heard him say, 'That Yuk Mui (translation: yukky ugly girl) is so stupid that she thinks that lending me her notes will get me to date her. She is so fucking ugly she's the last girl I would be seen with. But I will keep these study notes. They're not half bad! Haha.'

I cried that night, and many nights after. Dad was right: a beautiful apple can have a very rotten core.

I didn't know it at the time, but this experience changed the way I interacted with boys for many years to come. I became very sceptical when men showed any interest in me, that is, if they persisted long enough for me to realise they didn't just want to be my classmate, friend or colleague. I struggled with my appearance and rejected the slightest compliments. I put work ahead of my social life and believed for a very long time that boys would only break my heart – so why bother when I could

look after myself just fine?

What qualities do you look for in a companion? What did you learn from your parents about creating strong foundations for a relationship?

CHAPTER 22

Ask
And It Shall be
Given

In the year I joined ANZ as a management trainee through the annual graduate programme, only 120 of us were selected from 30,000 submissions. I already had two years of work experience with Sealord by then, so when I applied for the role of marketing analyst, I was able to demonstrate a deep knowledge of how market data could be used to support a sales team.

My manager, the head of commercial lending at ANZ, decided to add me to the graduate programme as I was still within the age range. He believed I would gain a lot of experience from moving around different parts of the bank and it would speed up my progress. He also wanted me to be trained in direct marketing, so that I could better design the upcoming campaign with the creative agency.

I love learning and relish the opportunity to apply it to real situations as soon as possible after studying the theory. Working with the creative agency reminded me of how much I'd enjoyed my marketing degree. I asked the head of marketing if I could shadow our marketing manager, who was leaving soon. I ended up doing both roles full-time, creating better invoice tracking for all marketing expenses, managing the relationship with the creative agencies and vendors and continuing to run the twelve-month direct-marketing campaign across all twelve sectors of the market.

I had been very lucky with my managers up to this point. My managers at Nu Skin and Sealord had encouraged me to grow, to step out of my comfort zone and to take on larger roles and greater responsibilities before I realised, or thought, I was ready. However, the manager who had hired me at ANZ took early retirement and I suddenly felt lost.

As a good Chinese girl, raised to be respectful of all elders in the workplace and the wider community, I had

always felt intimidated by older men, especially those who told me what to do. Instantly, I turned back into a five-year-old girl who knew nothing. So, when the manager who had offered me all these amazing opportunities left the business, I didn't know how to ask, or even that I needed to ask, for more opportunities to demonstrate my value. I just thought that if I worked hard and delivered consistent results, my new manager would notice and recognise my potential and promote me.

At this point, I had been doing both roles – marketing manager and direct-marketing analyst – for six months. Everyone else in the marketing team left work at 5 p.m., while I was still in the office at ten at night. I was also still on the same salary as when I'd joined eighteen months earlier, and there was no sign of anyone giving me a promotion.

One evening, the new head of commercial lending was reviewing the sales figure and asked me to give him another cut of the data. He said to me, 'What is happening here? This area should be growing.' He then walked over to the sales manager who covered the area and asked, 'What have you been doing in the last thirty days? Did you ask your top clients if they need new equipment? Did you ask them how you can help to grow their business? If you don't ask, how do they know how you can help them?'

Suddenly, it dawned on me. If I didn't ask, how would the very busy head of marketing know that I wanted the role of marketing manager and that I wanted to grow and learn more? It was not offensive to ask my elders. This was my career – I had to take control and stop sulking over my lack of progress.

I prepared a list of my achievements: of the savings I had made for the department and of the email testimonials from the agencies and vendors I'd worked with. I practised what I wanted to say in front of the

mirror again and again until my voice no longer shook. I asked for a raise to match the results I was delivering and the job title I desired. As I left his office with sweaty palms, I was quietly very pleased with myself.

It worked! I received both the raise and the title.

I realised that I had attached so much meaning to that simple two-letter word, 'no', and it had stopped me from acting. I had been so fearful of hearing that dreaded word for the longest time – it felt like death to me. It was so final, so brutal and I associated 'no' with failure, with the notion that I was not enough, that I was unworthy and that I had no right to ask for what I believed I deserved.

When the next opportunity came along, the chance to represent the New Zealand team and work at the head office in Melbourne, it seemed too far out of my reach, so I asked my new manager, the head of marketing, for advice.

He told me, 'Do just like you did with me six months ago, Victoria. Prepare and present your case. Ask, and if you get a "no", at least you will have presented your case.' He paused and seemed to read my mind. 'Victoria, "no" just means not this time, not now. It's not forever, it's not personal.'

I now encourage my clients to reflect on the stories they might have attached to their concept of 'no'. You might be surprised at how changing the story can open so many more doors that you didn't know existed till then. 'No' doesn't signify failure. The more 'no's' I collect now, the closer I get to the next 'yes'.

Perhaps 'no' means 'yes' to something even better?
Next Stop – Melbourne.

How do you react to the word 'no'? What emotions do you feel? How does it affect your decision making?

CHAPTER 23

Be Like Water

I went to Melbourne to work on our End-to-End (E2E) Process Redesign Project. I had never known that there were jobs that involved mapping out an existing process and then looking at ways to improve it. I later discovered that I had a natural talent for what I eventually learnt was called Lean Six Sigma work. Working with eleven amazing project members chosen specifically for their experience and expertise across different departments of ANZ, I was like a sponge, absorbing knowledge and technical expertise that I would otherwise never have encountered.

As we looked at the end-to-end process – from initial customer inquiry all the way through to settlement – I gained an oversight of the entire customer experience. Details never bothered me. What sometimes overwhelmed others, I rejoiced diving into.

I became highly competent in flexing and viewing each process from the ground up, speaking to those who did the job and collecting data, analysing them, categorising them and redesigning what they were used for. I observed and modelled myself on extraordinary project managers and communication strategists who knew how to work with difficult stakeholders. I learnt to bend and flow and be flexible. I felt like Bruce Lee, the legendary martial artist, who famously said, 'Be like water'.

I gained the skills needed to speak the language of those on the ground; I learnt to adapt and listen intently; and I became flexible in the face of all the different demands. I moved with the current, had a strategic vision and stepped out from the branches to view the whole forest. Dad said that I needed to think about what the next big thing would be. Not just the next move, but the next five. 'Don't wait for the next wave to come. Predict when it will arrive, so you are equipped to ride it.'

I decided I needed to master all the key tools

and invest in getting my Lean Six Sigma Black Belt qualification while working for ANZ. It was like studying for another degree at night and weekends, when I was already working long hours. I was no stranger to hard work and long hours, and I was living on my own in a serviced apartment in Melbourne city, within walking distance of the office. I made some new friends and enjoyed the city while working on my accreditation. It was going to be my side gig – my 'lateral complementary skill' that would give me a competitive advantage.

I thought problem-solving and learning were my superpowers, but as I met more statisticians and process engineers in this field, I discovered there was an opportunity to work in the niche market of actuarial consulting for a firm that developed its own patented software. This software predicted reserves in the highly unpredictable long-tail liabilities insurance and reinsurance market. I learnt that this company hired only highly technical statisticians and engineers, but there might be an opportunity to bridge the gap between the business's clients (insurance companies) and technical experts.

I played to my competitive strengths and started gamifying everything that I could find about insurance, reading up about its challenges and motivating myself with my own bingo sheet of tasks. This meant that once I'd completed each line of five different challenges I'd set myself, I would get a little reward. I would create little brain games to trick myself into doing them, marking them off in a table to log each time I'd completed them, when I would give myself a reward.

This was the start of my passion for neuroscience and for gamifying everything in my life.

I ended up joining Insureware as the only senior statistician without a PhD. I did not shy away from customer queries, and I certainly asked for feedback on

how we could improve the software to better serve their needs. I made suggestions on how to improve the interface and the user experience, and how to ensure we were continuously improving our software. I met many top-tier insurance and reinsurance actuaries across Europe and Bermuda, all the time developing my consulting skills.

I didn't know where all this could lead; I just knew that I was enjoying the next wave, and I trusted it would lead me to another period of deep learning.

When did you have to adapt to changes in your life that were beyond your control? What processes did you go through at this crossroads? How did you decide which way to go? What meaning or narrative do you give to the notion of 'failure'? How can you reframe this meaning to empower yourself rather than hinder yourself from acting?

CHAPTER 24

Sandbags

In 2005, I was eager to take my experience to London, just as I'd promised myself six years earlier. I wanted to use my big Overseas Experience (or 'the Big OE' as we call it in Australia and New Zealand) to gain international experience beyond Australasia.

At this point, I had worked in Hong Kong, Singapore, Japan, Australia and New Zealand, providing consultancy services for Asian and European countries, but I had not worked for any global Fortune 500 companies. I wanted to see the world before I turned thirty, and I knew that if I didn't try, I would always regret it.

I had seen many of my past colleagues set off for their Big OE and return two years later to significant promotions. It was my turn to see what I could do. I saved £4,000 and sent off my application for the Working Holiday Visa. I moved to London with four suitcases, and for the first four weeks I crashed on the couch of an acquaintance from church. She came from a wealthy family in Hong Kong, and I was not prepared for what I saw. On one occasion, we went to the birthday party of one of her friends, who lived in Highgate. What an eye-opener! I thought I was in the home of a celebrity. Everything from the Bang & Olufsen entertainment system to the Armani Home décor to the catering was first class. Even the children were dressed in immaculate matching Fendi outfits, and their hair had been blow-dried and styled. It was like entering another world.

How was it possible that I had never attended a birthday party before? I later found out that my mum had thrown away every single party invitation I'd ever received in kindergarten and primary school because she believed that if I were to go to any of them, and discover what the other children's families had, I would be miserable. The contrast between what my classmates had and our

humble home life was something she refused to expose me to. Of course, since I didn't go to those parties, we never had to invite anybody back to our home and so the invitations quickly stopped coming.

Perhaps she was right. Perhaps my five-year-old mind would have struggled to handle the chasm between my home and those of my classmates at my prestigious school.

This birthday party experience in London ignited a spark in me that I didn't know existed. I wanted to create a comfortable life where I too could throw extravagant parties and have friends over to my house. I wanted my parents to be proud of the place they lived in and no longer have to worry about money or status.

If I couldn't make it happen in one of the world's largest financial centres, then where could I possibly achieve financial security?

I had lined up six interviews for my first week in London in October 2005. I bought myself an A–Z and set out to navigate around London for the interviews. Dressed for the rain and the cold, I was ready to show my future employer that I was ready for London. I hoped London was ready for me.

I got my first role at Morgan Stanley in Canary Wharf. It was like walking into Lower Manhattan or 45 Rockefeller Plaza. I knew no one, and my first role in the project management office paid just seventeen pounds per hour – less than half of what I had been earning in Australia. Unfortunately, the cost of living in London was double that of Melbourne.

I was determined I would not let my family down or make them worry. I would not be defeated. I would prove myself anew because all my experience in Australia and New Zealand was worthless and irrelevant in this new market. I would save every penny, go the extra mile every

day and help everyone in my team in any way possible. I would learn the technology we used to code for the team, so I could create reports that would show how trades could be settled even faster. I would be unstoppable!

When Dad asked me how London was, I would smile and say, 'Fantastic! I'm learning every single day.' I didn't want to share any of my fears and doubts. I would save the phone cards I bought in Chinatown and make sure I delivered happy messages to him every single week.

I remember, on a weekly basis, my managing director's guests asking me if I could bring them coffees. I remember being asked where I came from and about my accent. I remember being asked to fetch printer paper, as if I were the new secretary. I remember smiling politely and keeping my head down – and working even harder.

I took every opportunity to meet new people and learn more about investment banking. I attended town hall meetings to learn about the market trends and how each department was performing. I took notes and read every single newspaper left in the staff common area. *The Wall Street Journal*, *The New York Times* and the *Financial Times* became my best teachers.

One of the joys of working for Morgan Stanley was the huge number of activities available to staff, many with significant corporate discounts. I joined groups that loved art galleries and live theatre – I went to all the musicals and plays I had dreamt of seeing, and I even started taking salsa lessons.

One of my dance teachers was a stylish lady from Bulgaria. I admired how elegantly she danced, and I would watch her move around the dance floor in awe. Confident and mesmerising, she owned the whole room. She told me that back in Bulgaria she had been a gymnast. Her gymnastics coach would strap sandbags to her ankles and make her train and move this way. She said it was

very difficult at first but, once she'd mastered it and the sandbags came off, she *flew* in competitions.

I took this to heart. If I could consistently exceed expectations in this country where I was a nobody, where I had no connections and where I rented a tiny bedsit in East London, then, once I'd built a reputation and embodied her confidence, I too would *soar*.

So, I began mirroring the way she walked. I imagined what it would be like to move elegantly and confidently through the boardroom while continuing to deliver exceptional results at work. From Morgan Stanley to the Royal Bank of Scotland to Barclays Capital, I became one of the youngest female directors in investment banking and mentored multiple cohorts of new female recruits in the following years.

What does financial freedom look like to you? What are the sandbags holding you back from achieving your greatest potential? Who can help you to identify these areas so you too can soar?

CHAPTER 25

The Corporate Game of Snakes and Ladders

Looking back, there have been many times when I allowed others to overstep their boundaries. How could I have stopped them? I didn't even know what boundaries were.

Not only is it culturally frowned upon in Chinese culture to say 'no' to elders but it is also expected that you earn your stripes and take the work. My parents didn't teach me how to say 'no,' how to push back or how to protect my mental health. I didn't know that the way in which I was being treated was unacceptable. Dad had always told me to respect the person who pays your salary, and never talk badly about your colleagues or managers.

Even when something was unfair, and when he was doing better than his boss's son, he never complained or said a bad word about them. He said that, like driving, I needed to stay in my lane and focus on what was in front of me, not critique how others were driving in the next lane. So, I thought that questioning and challenging my seniors about their ideas was forbidden and career limiting. I struggled to share my own ideas and speak up at meetings. It was as though my throat chakra had been blocked.

Maybe this was the reason I found it difficult to voice my opinion to authority and why I developed a huge fear of superiors and those who were older or had more experience than me. The stories I had been telling myself had stopped serving me, but I didn't know how to break out of the cage I had constructed for myself. My traditional beliefs and cultural influences had become the chains preventing me from growing in a Western world that required and expected me to speak up and challenge the status quo.

It wasn't until I met a senior director at Barclays Capital who embodied the intellect, strength and assertiveness of a leader that I realised that one can be a successful business leader, a woman, a mother and a

wife. And she still had time to study for an MBA at the prestigious London Business School, manage over 100 people and deliver consistent results. Even with small children at home, she was never late, and she always looked professional. She stood her ground and protected her team; she was clear about her expectations.

Initially, I was intimidated by her and terrified of making mistakes until one day she took me aside and said, 'Victoria, I liked how you handled that problem during the last project meeting. Now, tell me how you will solve this problem.' Her name was Cosette, and she empowered me to be the best version of myself. She gave me opportunities to try and fail (within reason), she allowed me to ask stupid questions and, most of all, she showed me that I could set boundaries without damaging relationships. She introduced me to a coach, who helped me work on my blind spots, and I learnt to move on from many of the unconscious behaviours that were part of my earlier programming but which were no longer serving me well in the corporate world.

In 2008, I embarked on a personal and professional development journey. Starting with improving my communication skills with neuro-linguistic programming (NLP), I then moved into using techniques from Virginia Satir and Milton Erickson to role-play, study, document, learn and then model how other senior managers behaved to inspire and influence their immediate teams and others.

I then experimented and applied these learnings to my own style, noting down the results, tweaking and refining my processes until these techniques became natural to me. This arsenal of skills has led many of my colleagues to view me as an extrovert, and they are often shocked to learn that every personality test concludes that I'm an introvert. I also used NLP techniques on myself to overcome my internal limiting beliefs and reframe some

of my fears.

Next, I incorporated emotional freedom techniques (EFT) and Amygdala Depotentiation (more commonly known as the Havening Technique: a step-by-step process that puts your emotional responses into a safe space – a haven) to self-soothe and deal with my anxiety. I also used Danielle LaPorte's Desire Map to identify my core desires and values, and I incorporated daily rituals, including Morning Pages and journaling, to help me unlock my creativity and free my inner child.

As I moved up the corporate ladder, I faced new and different challenges. There's a saying, 'New levels, new devils', but my desire to better myself continued. I began learning more about different communication styles, facilitation skills and non-violent communication techniques, as well as how to sell, how to influence and how to negotiate. I spent at least 20% of my annual income on my personal and professional development. I would attend courses at the weekends and then practise what I studied with my project team members. When I teach, I learn twice. As I continue to help others, my career continues to grow.

I knew that my dad's experiences in life were different from mine, and I couldn't possibly imagine sticking to just one or two jobs for a lifetime. He was eager for me to find a good job with a well-known, safe, reliable employer, where I could work my way up the ladder. He wanted to know that I could look after myself financially, so he could feel secure, knowing I was safe even if I was a twenty-six-hour flight away.

I never shared with him that I was bullied, but I'm sure he knew that life in the UK wasn't all roses. I never told him about the time I didn't take a job after the hiring manager suggested a 'work trip' together, sharing a hotel room, and how I was then gaslighted by the female

recruitment agent and told that I must have heard wrong when I told her why I'd be declining the offer.

I don't regret not sharing these details with Dad. What would have been the point in making him worry about me on the other side of the planet, when none of these problems were within his control or influence? He would have lost sleep for nothing. I had to learn to be stronger, to get up faster and to create the golden shield, just as he'd taught me.

Some of the inner work and reflective journaling were incredibly painful. I had to look within and acknowledge and accept some of the damage I might have caused others by being a perfectionist. A new level of awareness allowed me to improve and realise that my obsessive need to be perfect, to check everything and to create fail-proof designs and processes was alienating my co-workers. Some of them started to find ways to discredit my work and would complain to management that I had given them unrealistic goals and targets. Some said, 'It's impossible to meet Victoria's expectations. Just because she can do it, and stay at work till midnight, doesn't mean we can.'

On reflection, I think my obsessiveness came from the fear that, if I let go, whatever needed to happen might not happen. I was afraid of being disappointed and of disappointing others. When I really looked closely, it all came from an overinflated sense that no one could possibly do things as well as I could – or even do them at all. I didn't give my team the space to step up. I thought that if I wasn't spinning all the plates and carrying all the tasks on my shoulders, everything would come crashing down.

The truth was that I could have trusted my team and shared the load. I could have delegated and supported my team to take on more responsibilities. I could have

lowered my expectations – not everything can be done comprehensively to the nth degree, and sometimes they *shouldn't* be (except for risk and compliance!). As one of my mentors kindly reminded me, 'Victoria, sometimes you can't have all the information. It might be physically impossible. When the examiner says, "Pens down", it is pens down. You can't keep going. You can't work in the night when everyone is asleep. You have to let go. That's why it's so important to prioritise the 80% first, so that when the pens are down, you know you have put your best foot forward.'

How do these kinds of issues show up for you? Terri Cole, clinical psychologist and author of *Boundary Boss*, calls this behaviour 'over-functioning', which is very common in high-achieving women, when we are holding on to the reins so tightly that no one else could possibly get a hold of them. In what areas are you micromanaging people in work or at home? Where are you doing more than your fair share? How can you appreciate your colleagues and friends more and trust they can help you?

Does perfectionism show up in your personal or working life? If so, where does it help and where does it hinder you? Are there some occasions when 80% is good enough?

Is there a dark side to your obsessions? How do you stop yourself from going there? What are the warning signs to look out for before burnout?

CHAPTER 26

Swan Lake

When I told Dad I wanted to become a chief operating officer (COO) and support a global team of 700 staff, he asked, 'Why would you want such a thankless job? When things go well, no one thanks you. They expect it to go smoothly, but if anything – anything at all – does not go as planned, you are the first person to get screamed at.'

Was I sure this is what I wanted to do to change the world?

'If it is, then you'll need to learn to harness your patience, to stay calm and be like the graceful swans you see at Regent's Park. All people see is the effortless glide. Underneath the water, no one can see how hard you are paddling to keep moving.'

That was how I ran my life every day at Deutsche Bank. No matter the chaos, the disasters or the fires that broke out, I pictured myself gliding. I needed to show the team that nothing would knock me off my equilibrium. We would tackle anything that was thrown at us and we would succeed.

What I didn't recognise early enough, though, was that my health was deteriorating. I was functioning with a level of stress that was beyond human endurance. I barely slept, and I was suffering stomach cramps. I went to see multiple gastrointestinal specialists and none of them could give me an answer. Every scan and test under the sun came back negative. Then one day a doctor asked me, 'How stressful is your job? Do you think this stress could be causing all of your problems?'

I was in denial. Come on, there was nothing I couldn't hack! Maybe I could try mindfulness. If I could trick myself into doing twice-daily transcendental meditation, I could build any habit into my life. Goodness knows how hard it was for me to slow down and sit still. Surely, there was something else I could do? I was stronger than this, I could beat it.

Every problem I'd ever had was something I could 'process-improve' my way through. If I ticked my chart every morning to log that I'd managed to do my meditation or breathing or chanting or whatever, and if I ticked it every evening too, then surely, after thirty consecutive days, I would be a success? That was how Victoria Liu worked. I would then reward myself with a bubble bath or a fashion magazine.

But when was the last time I'd actually had fun? When was the last time I'd given myself time off to just *be* instead of *do*? There was always another problem to fix, another incident to resolve, another crisis to deal with. And while I worked flat out to fix everybody else, I deferred – again and again – my own gratification.

I had perfected the art of delivering consistent results, treating my body worse than a machine, pushing it to do more, my focus always moving forwards no matter what. Whatever I'd achieved this time, I had to do better next time. I was yelling at myself like a drill sergeant to achieve even more and faster! I was missing and bypassing all the cues from my body, suppressing what was happening to me, numbing the pain with medications instead of sitting with the discomfort and listening to my body. I neglected my body's wisdom and tried to override it with logic and even more unrealistic targets. So, my body presented me with more problems for which there was seemingly no cure, forcing me to slow down and pay attention to my own needs.

As a child, I'd learnt that it's not OK to throw tantrums or scream; I had suppressed these powerful emotions. I believed that it was not safe for me to express these emotions – Mum and Dad would not love me if I misbehaved. Subsequently, I had no outlet through which to release my fears and my anger. I didn't know that these emotions are then stored in the body over time until it can

no longer contain them.

That was how it was until December 2018, when someone very close to me was diagnosed with stage 4 cancer. It hit me straight between the eyes that there is nothing more important than health and community. I took unpaid leave and eventually resigned from my job when his chemotherapy became less and less effective. I stayed by his side until his last breath, and I realised that some things truly are more important than work, salary, success and a fancy job title.

Do you know what your body's early warning signs are, and how they can alert you to a potential burnout? How can you connect with your body more regularly, to be more aware of these signals?

CHAPTER 27

Beyond Corporate

Just six months after my friend passed away, I was working for BlackRock and preparing to fly to Budapest to meet the new team there. My mobile rang with an unknown number. I picked up and heard my mother's shaky voice: 'Dad's collapsed,' she said. 'What should I do?'

My heart stopped. I had seen him three months earlier and he had been healthy. I had spoken to him just two days earlier, when we had joked about the neighbours. This couldn't be happening. What had gone wrong?

I quickly organised a flight home, cancelled my work trip to Budapest and got on the next flight to Hong Kong. It was December 2019 and a strange new virus was making the news in Asia. It wasn't clear whether I would be able to fly to New Zealand via Hong Kong, but I had to try because it was the fastest route home.

My journey was the longest, most unsettling twenty-six hours of my life. I don't remember what I did, what I watched, if I ate or whether I slept. I arrived at Auckland Airport, not knowing where I should go – home or the hospital – or how I would get there. And then I saw my brother … and I immediately knew … Dad had already left us.

I didn't get the chance to say goodbye to him or to see his smile one more time. Never would I hear his voice again or receive his encouragement. We quietly said goodbye in a small, private ceremony.

We brought peonies, his favourite flowers, and the make-up artist did an amazing job. Dad would have wanted to look perfect for his final performance.

Mum was never the same after that; perhaps none of us were. I used to define my life's work and achievements in terms of whether they would make Dad proud. My success was my way of honouring my father's sacrifices.

Before Dad left, I had never thought I would want

a life beyond the one I had with big corporate employers. I couldn't imagine giving up being a COO or a chief of staff. But his death showed me that these were nothing more than fancy business cards, and they didn't define me. I knew that I wanted to honour my father's eight-five years of love and labour by living a life that was joyful, healthy and fulfilling.

I could no longer speak to Dad and ask him for advice, nor could I get his permission and blessing to move on and leave the corporate world that had drained my soul. I was stuck in grief and sadness, and it was a conversation with my then coach Jeremy that showed me the light.

He said, 'You have tried everything to coach yourself out of this. Have you considered that you are looking at it all wrong? *You* are not the problem. No other certification will fix this. You have been tirelessly helping everyone, supporting your team and coaching them. Do you think it's time to give yourself a break and figure out what *you* want? You can always find another job once you're ready. There will always be another corporate job when you want one.'

It took three panic attacks and a bout of uncontrollable crying during my Sunday bath ritual, which I would normally enjoy, for me to realise that I couldn't even get myself out of the lukewarm bath water. I was stuck, lost and exhausted, and I needed help. I knew something had to change.

From a place of despair, I surrendered. I didn't know what else I could do. A friend called and suggested I see her Reiki master. I went and had no idea what happened – I cried for what seemed like hours. I felt as if I were in a different place. When I returned to the room, my chakra was unblocked, and I could finally see I had lost myself in my job. I had to give up the identity of

'the good girl' to reconnect with myself, to choose me and not put my team, my boss or my job title before my own needs. I was not my parents' missed opportunities. I did not have to carry the obligations of their unfulfilled dreams. I could create my own future and give myself permission to live the life I wanted.

I was so used to wearing the mask my parents had given me that I didn't know how to take it off – because I had forgotten I was wearing one! This awareness gave me the clarity to decide. I always had a choice, even if it was something my parents would disapprove of.

It took a week at a silent retreat for me to realise that Dad would not have wanted to see me suffer. His passing had given me the permission I needed to create the life I wanted, to build a future where I could use my skills, experience and knowledge to help other migrant women overcome their obstacles and create better lives for themselves, their families and their communities.

This is how I want to be remembered – for creating an environment in which those around me can share, grow and learn together. Even though this is my adopted country, I want to create a place where we all feel that we belong and that we are equal, where we can freely exchange ideas and help each other in creating a healthy, harmonious and sustainable home and work life.

I wish my dad had had the support I am now providing to the wider Asian community: how to find work that is aligned with their Asian work experiences and how to better articulate their skills and experiences to prospective employers. I wish he had known where to go for help, and how to ask for it. Although I wasn't able to help him when I was twelve years old, I am now approaching the age my mum was when we moved to New Zealand, where we had to reinvent ourselves and our lives. If I can help those who are struggling to settle

into the UK, or another country they now call home, I will be making the positive impact I want to see in this world.

Settling in a new country is no small feat. I have lived in many countries and every time I uprooted and moved to a new city, I had to summon strength and perseverance from the deepest part of my soul. As an introvert, it takes me a long time to build relationships, although they are deep and strong once forged. I found it exhausting to socialise and mingle with new people. I would encourage migrant parents to take the time they need to allow themselves the grace and space to grieve for the parts of their lives they have left behind, the old identity they have lost, the friendships and community they once had.

Be kind to yourself, don't rush, and don't just focus on what is ahead of you. Pause to acknowledge and celebrate what you have achieved with your family, the new friends your children have made, the neighbours who now join you for tea. Notice the confidence in your children's voices when they tell you all about their new school and new activities. Don't beat yourself up at the parent-teacher meeting, don't expect to be a 'local' right away, don't get mad when you don't know what is going on in your city or if you miss a local event.

It takes time. Eventually, you will get to know your surroundings as well as your previous home. For now, it is good enough. Let your family know how proud you are of them. Adapting to a new country is incredibly challenging, and it requires constant effort – only those who have moved can understand your struggles. Local slang, idioms and the ways in which the locals like to interact can take a long time to learn and adopt. We are not only reinventing ourselves and creating new identities in this new world but we are also coping with the stress

and sadness of losing our sense of self and missing the home we left behind. To all migrant families, and children of migrant families, I want you to know that you are doing great. All in good time.

There are many cultural differences at play when bringing up children. Many people perceive Asian parents as 'tiger parents'. It is the only way that Asian parents know how to cope with the challenges in their changing environment. I used to think that being the perfect Asian daughter and being the classic overachiever were my life goals: to make my parents proud. But it took my dad's passing and my burnout to realise that there is far more to life than getting trophies and awards.

I would encourage young migrant parents to loosen the reins and let your children stumble and figure things out on their own while you watch from afar, letting them know you are there to support them. Nurture them and provide them with more opportunities for experimentation and play. Encourage them to develop life skills, such as volunteering and working within the community, which are far more important than just getting good grades and going to the top universities. Support them in building relationships and encourage them to create their own communities based on their interests. Collaborate with others and learn to communicate effectively with people with diverse backgrounds and experiences. Most of all, celebrate and recognise their achievements across a wide range of pursuits. Share your own experiences and learn from those who have emigrated before you.

Have you ever taken the time to assess (perhaps with the help of a life coach) what is truly important to you? What are the potential costs of not doing this work?

CHAPTER 28

The Road to Healing

My parents did the best they could, based on what they knew at the time. Even though some of their actions caused pain and trauma, which I am now working through, I know their intentions were good and they wanted to provide for and protect me the only way they knew how.

As Elizabeth Gilbert, one of my favourite writers and teachers, once wrote: 'Never waste your suffering. It is not the tragedy that creates your alchemy, you have to experience it, transform it and become the alchemist. Don't waste your suffering. Suffering without catharsis is nothing but wasted pain. And you should never waste your pain, never waste your suffering.'

I am my own alchemist. I shall meet my pain with curiosity and openness, I shall use it and I shall transform myself with it – I shall learn from it and grow.

My struggles and trauma are ultimately the strengths and insights that have helped me to overcome each hurdle. I am writing my story for all the daughters of migrant parents, so that the many generations of wisdom embedded in us can give us collective strength and courage. And in this way, I can also honour my parents' sacrifices and unconditional love. As Brendon Burchard always says, 'Honour the struggle'.

My parents decided to leave Hong Kong when they were already in their forties and fifties, with no employment prospects, without friends or connections and with qualifications and experience that, at the time, were not recognised by the New Zealand government. Now I'm seeing my own school friends making the same difficult decision to take their children and families to New Zealand, Australia, the UK and Canada – starting over in a foreign country, in a new world where everything is done differently and familiar things must be abandoned. Just as we can't help a caterpillar that's struggling in the cocoon before it is time to emerge and become the butterfly it is meant to be (if we do try, we will kill the latent butterfly),

we can't prevent our children from making the mistakes we made. They have to learn and go through the growing pains themselves.

My childhood was not a lot of fun. My therapist pointed that out and it took me over a year to realise she was right. But I didn't have a comparison; I didn't know what fun look liked. I learnt to gamify everything as my form of fun. I developed a deep desire to be my very own taskmaster, expecting more and more from myself every day – judging and punishing myself to achieve more against an unrealistic standard. My survival method was to push through, to try harder for a solution that would eventually come. Overachieving became the new norm for me: there was always a higher mountain to climb and more competitions to win, so I could bring home more trophies to make my parents proud after all they had given up. I had to prove that I was worth their sacrifices.

Seeing how hard my parents worked to pay the bills and keep a roof over our heads, I wanted to free them, and others, from that burden. I wanted to be so low maintenance that I almost vanished. I wanted to free them from the trials of looking after me and my needs. I thought that if I couldn't contribute, at least I could stop asking for things. I learnt to adapt and not to be a burden, to the point where I lost my sense of self and any connection to my own needs.

Anything I could not rationalise, could not figure out with logic, was put into a separate box. There was no time for emotions, no time for redundancy, and if I could be delightfully tiny, low maintenance and helpful, then I could eliminate some of the stress around my parents, my boss and my community.

Alas, hard work lost its correlation with results and success, and taking on more didn't make me irreplaceable or more appreciated. There were no rewards for the highly sensitive person who put everyone else first – the

only reward was burnout.

I once heard the story of an early Antarctic explorer who was crossing a sea of ice one day when a sudden blizzard struck. He was forced to build an igloo and take refuge from the storm, which raged for a couple of weeks. After a few days of sheltering, he noticed the inner walls seemed to be closing in on him and it wasn't due to an hallucination. The moisture from his own breath was forming a thin layer of ice on the walls each time he exhaled, causing the walls of his igloo to thicken. The once safe igloo was becoming his prison as the structure slowly closed in around him.

My desire for survival and safety in a new country had led me to build a defensive mechanism that slowly turned into my coffin. I had to let go of what had once served me: the shelter I had built to survive the storms of my childhood. It no longer worked; it was now the problem. My learnt behaviours and strategies were now the very things blocking my way. I needed to face a new frontier by adopting new skills and developing new strategies, rather than hiding from the storms of my memory.

I needed to reconnect with my intuition, the intelligence of my body, and to be kind to my mind as I relearnt, realigned and returned to the right path. What I had once needed to defend myself against my past was now blocking my present and my future. This is my ongoing work.

Not all my lessons have come from my father; some of them are methods I have developed in order to survive and to try to fit in.

Warning: the following paragraphs contain material that some might find disturbing. Reader's discretion is advised.

I never told my dad about the boss who used to sneak up behind me and pull my headphones off, asking if I was on an important call or just pretending to work. Or the boss who used to threaten me by raising his hand to see me flinch. Then there was the boss who told me he wanted to pull my long black hair because it annoyed him, and he wanted to see if it would break as easily as blonde hair. And I certainly couldn't have told Dad about the boss who was annoyed whenever I said 'no' to his invitations for drinks after work.

I never told him about the times Scott marched out of his office with a murderous look on his face and everybody in the room knew that someone was about to become the victim of his abuse. He would shout, 'You idiot! What did I pay you for?!' Many times it would be me that received the abuse, as I was closest to his office. I might not be a genius – but I am far from being an idiot.

I never told him about the times Tony would call me a 'useless idiot' in front of my entire working group just to get a reaction. He would then leave for a long 'work lunch' with a 'client', from 12–3 p.m., only to return reeking of alcohol. He would then tell me to cover all his meetings (as if I had nothing better to do) because he had a headache.

I never told him about 'Stupid Asian girl, why don't you go home and cook some rice? Shh, the men are talking!' during my own Steering Committee meeting for a programme I was leading. Or the regular microaggressions from my colleagues about the way I dressed: 'Oh, you are so fancy, we clearly pay you far too much.' Or the comments about what I ate: 'Aww, Victoria only eats healthy food. She wouldn't want to eat from the chippy like us.' This doubled up as an excuse not to invite me to their Friday lunches.

I never went to Human Resources (HR). As chief of staff, I had been through many employment-relations

investigations involving our various HR business partners. I know they are hired by the company to protect the company's interests. They are certainly not there to look after the employees, and never will be. I naively used to think that if I could just speak to HR about a problem, they would make it stop, but I have witnessed so many cases that I now know that complaining will only make them turn and hunt you down, push you out and label you as the one at fault – the one who lacks resilience and who can't cope with different leadership styles.

The traumas of my industry stayed with me, corrupted my spirit and forced me into a series of adapted, learnt behaviours that I used for my own safety. I learnt to suppress my feelings, to live with the anger and abuse until my gut could no longer cope.

I learnt it's best to evade predators and to stay small. I discovered different ways to camouflage and shield myself. I realised that having a sensitive nature is not helpful when your work environment is psychologically dangerous. I found ways to compartmentalise my life, my feelings and my speech so as not to let others discover areas they might choose to exploit.

Today, as I finish this book, I am still working through these traumas with the help and compassion of other people. Maybe one day, when I am healed and ready, I will share in another book some of the methods I have used to overcome these corporate traumas.

What do you need to let go of in order to move forwards? What stories are you telling yourself that are stopping you from moving on? Who do you need to forgive (including yourself) for the past hurts that you're still holding onto?

CHAPTER 29

Festina Lente

The first time I sat in my integrative therapist's office, I took out my pen and notepad and asked her, 'Can you walk me through how this works, the number of sessions, the structure and agenda for each session?'

She said, 'What do you mean?'

I said, 'How many sessions do you think I will need to be fixed? And what will we be covering in each session so I can best prepare and work towards the goal. I want to see your plan.'

Four years later, she still laughs about it.

'Oh, let's start with twenty sessions,' she said and smiled at me as if to say *be patient, the journey has only begun.*

I was frustrated, angry and annoyed with myself. I wanted to be there already, so why was I still here? I tried to fire her many times, in my head, but somehow, she found a way to make me sit with the uncomfortable, sit with what is uncertain and reflect on my inner world. She got me to stop chasing one goal after another and to simply just be, in the here and now, to find myself, talk to my inner child and accept that I cannot be the perfect daughter fulfilling the lost dreams of her father and mother.

The Value of Going Slow

I was baptised in St Margaret's Church, Happy Valley, Hong Kong. It was a warm and friendly parish and all the priests spoke Cantonese, even though many of them were from Eastern Europe. Whenever I ran from Sunday school to choir practice, Reverend Father Gambaro would stop me and say 慢慢行, 快快到; this literally translates as 'Walk slowly and you will get there quickly.' I didn't understand at the time; in fact, I thought the Reverend Father must be confused. Why would slowing down help me to speed up?

My modus operandi is to push through at lightning speed, to be efficient and productive. I associated my value with the widgets I produced – who am I if I'm sitting still and not producing something? What value do I have if I am just being? I did not want to feel the uncomfortable feelings – the stress, the anxiety, the grief, the anger – I had been suppressing all my life. I didn't know how to process and deal with my sadness. I have never learnt how to do this; my awareness of my internal signals was poor and I thought that if I could outrun the quicksand, I could escape these somatic discomforts and focus on the next vision.

I was creating a future so I didn't have to stay in the present. I was trying to bypass the immediate moment. But it didn't work. My body refused to let me off the hook. I was in so much pain. I couldn't physically run away from myself and I was forced to slow down and be still.

Looking after my energy became my top priority. I hated it – having to deal with my emotions and listen to my body. I had to learn to pay attention to my body and my nervous system and learn how to self-regulate. I learnt that I cannot pick up a new positive habit in a state of fatigue, so I needed to learn to honour the fatigue, be with the discomfort, not push harder or beat myself up for not already being there. I had to unlearn some of the lingering patterns of numbing myself and pushing through, and I had to learn new patterns.

I had to allow myself the space and grace to sit with unpleasant feelings and be curious; to give myself permission to explore and create a much broader definition of success – slower living, more mindful, more sustainable, letting myself *be* rather than *do do do* while piling on more self-judgement and shame. Prioritising rest and recovery is not laziness. Ask any top athlete and they

will tell you that the rest period is even more important than the training period. The muscles cannot grow if they do not have time to heal and recover. Our bodies are the same: they need to heal from trauma, and our nervous systems need to recover and reset, just as muscles need to heal from strength training.

Being present leads to healing because by focusing on what causes us pain, we often discover that the solution presents itself. Being present helps us to tap into the body's wisdom, which knows where we need to go to heal.

The work I had to do concerned my emotions. I was to sit with my discomfort and listen to my body, not rush into analysing it or find ways to fix it – just listen to what my body needed from me and give it my full attention. The most valuable asset is attention; it's what our children and our partners want, and it's what our bodies want.

We can't hurry healing, but when I let go of control and trust myself, my body and my mind work together to create magic beyond my imagination. My pain disappeared and I now know the importance of slowing down so that I can listen and pay attention to what my body or my *part* is trying to tell me.

Intergenerational Trauma

In 2023, one of my mentors recommended I work on the guilt I felt for being so far away from my mother, who had been living on her own in New Zealand since my father passed away. The strain peaked after she broke her hip and none of us was aware of it. I felt so much shame despite the fact there was nothing I could do from London. After she was discharged, following hip-replacement surgery, I flew home and became her carer. I helped her with her

daily physiotherapy, her meals, her cleaning and yet, the guilt and shame did not lessen.

Three months later, after her physiotherapist had discharged her and her mobility had returned completely, I returned to London. I was still fearful of her living situation, and I started having more and more conflict with my brother around her care arrangements. I wouldn't be able to help if something were to happen to her because it would take me over thirty hours to get there. I couldn't resolve any of the negative emotions I was feeling. My mentor suggested I try family constellation therapy, which is a special type of therapy that involves a group of individuals, usually strangers, who act as stand-ins for the client's past and existing family members, to create the client's family system/constellation. During the session, the client can experience therapeutic or transformational moments with their relatives and explore some of their history of which they might not have been aware.

During one of the sessions, I engaged in powerful therapeutic dialogue with my maternal grandmother, who had suffered significant loss and trauma during World War II. The effects of this trauma had been passed down to my mother and then to me. The study of epigenetics demonstrates how our bodies can adapt by adjusting gene expression and how some of it can be passed on to our children. Although these changes are not definitive, we can work with them and rewrite our own life experiences and reactions if we are aware of these adapted traits (for example, increased risk for PTSD, anxiety, obesity, diabetes, etc.).

Whatever type of generational pattern you inherited, your responses to it are likely to be part of a cycle. I am still working on this across my own family constellation as I continue to explore my family history and trauma. My goal was to break the cycle of the

intergenerational trauma of my ancestors, so that I could grow beyond their traumatic past experiences and create something new and beautiful for me and those around me.

My family history is not my identity. I cannot control what happened in the past, what happened in my mother's womb or in my grandmother's womb and so on. Breaking the cycle of past generations' trauma takes courage, patience, self-love and kindness. I can now use the past generations' wisdom and experience when they serve me, and I know that those who lived before me are watching over me with pride as I pass on my experiences and lessons to my own community.

I believe my purpose is to help many other perfectionists and overachievers to find their soul's purpose without compromising their values or health. I want to help them to identify the limiting beliefs and coping strategies that no longer serve them. I hope I can continue to help them to reframe and redesign new ways forward with ease and joy. I believe we can all find the road to healing our personal and professional trauma via self-acceptance, patience, curiosity, kindness and quiet perseverance. This way we can achieve what once felt impossible.

This is my superpower.

How would going slower help you to speed up? How can you help others? How can you serve humankind? What is your superpower? What is your soul's purpose?

CHAPTER 30

Net Worth

When I started to study neuroscience, I soon realised that my dad was way ahead of the game. He had decided to keep his brain active so that he would not age like his peers, and he would remain active, doing everything he wanted to do, until God summoned him.

And that's exactly what he did. He was a huge believer in rituals and believed that healthy routines would help to keep him lucky. He would wake up at the same early hour every day and drink his morning cup of chrysanthemum-flower tea with a spoonful of UMF 10 manuka honey. He then practised tai chi and went for a walk, no matter the weather. Up until the day he died, at eighty-five, he was active, with full cognitive functions. He was giving us his orders and sharing his opinions right up to the end.

He would play a numbers game (similar to sudoku) and read his daily newspapers to find out what was happening around the world. He monitored the foreign exchange rates for the pound sterling and NZ dollar and always knew the rates whenever I called. He would ask me if I knew how much the rates had moved and if I had invested.

He kept track, in his mind, of the prices of things he bought regularly. He remembered the delivery times and dates of the local Chinese grocers, as well as their names and those of their partners and their children. He would always greet them by name and ask about their kids. He remembered their ages and the schools they attended, and he bought them little gifts for their birthdays to show his appreciation.

Dad always said that we should look after others and they would look after us. Treat people the way you want to be treated. Don't be stingy about showing your appreciation. Say thank you more often than you think you need to.

Your net worth is your community, your long-term savings account of friendships. Your network is more valuable than money. Without community, you cannot survive. When you are able to do so, look after the people who need help. Don't invest in people in expectation of returns; one day they might come anyway. Invest your time and wealth in others and it will be returned to you many times over. And never ask anyone for a favour until you have first invested in them.

When Dad finally left us, I realised how much his lessons had helped me to create the stable, loving and rewarding life that I now have. I work for myself, helping heart-centred, purposeful leaders, business owners and entrepreneurs achieve their goals. My goal is for them to find balance and to create truly meaningful lives that are sustainable, kind and in alignment with their purpose and vision. My riches are indeed my network of wonderful, nurturing and amazing friends, fellow entrepreneurs and colleagues.

What is truly valuable to you? What might you do to attain more of what gives you joy and nurtures you? And how might you shed the things that drain you?

- Epilogue -
The Burgundy Briefcase

In March 2020, I went home to see Mum, who had not been coping well since Dad had passed away in December 2019. Shortly after I arrived, New Zealand went into full lockdown to protect the country from COVID-19. No one was allowed to enter or leave the country.

I was tidying up Dad's study when I noticed his burgundy briefcase, carefully protected by several pillowcases. Like everything my dad had owned, he had kept it very well. It had just a few barely noticeable marks from gentle wear and tear, and the lock had rusted a little. The smell of leather was still very strong.

Way back in Chapter 2, I wrote about how Dad had rushed into our house after it was burgled to find the

briefcase. For years I had been curious about what was inside that case that was so precious to him. I remember how relieved he'd looked when he found out it hadn't been taken. He cared far more for it than for more obviously valuable items, like watches and pens.

I couldn't open the case. It was locked. Mum said she didn't know how to open it and showed me where Dad usually kept his keys, in a little rusty Parker Pen box. After trying many of the keys, I finally found the right one.

Click.

I asked Mum if she knew what was inside. She said that she had never questioned Dad about his private matters and then she left the room.

My imagination was running wild. Would there be photos of a past girlfriend? Love letters? Mysterious gifts? There were so many possibilities. Could it be his private collection of treasure? Dad always loved fancy pens and watches. He had saved to buy his first Rolex and got one even before his boss did.

As I eased opened the briefcase with anticipation and excitement, I was not prepared for what I would find.

None of the things I had imagined were inside. I found another pillowcase and inside it were all my school report cards from kindergarten through to my high school graduation. All of my certificates of achievement from school, and every award for my coming top of the class was there. Each was gently folded in clear plastic holders. He had saved the birthday cards I had drawn for him when I was little, their crayon powders smudged and faded but still in very good condition. And there was his first Parker Pen, with a slightly rusted tip.

I don't remember how much time passed as I

flipped through each report card. I had never felt so sad in my life, and the Disney movie *Inside Out* came to my mind. I remembered how deeply affected I was by the character Sadness. I had an overwhelming desire to lock her away to stop her causing chaos (she was only making Riley and Joy's life difficult, I thought), and I wanted Joy to get on with running the show. I know it was just a cartoon, but it reminded me of how much I wanted to bring only joy, good news and happiness to my parents, how I never wanted them to see my sadness or anger.

I realised in that moment, as I cried into my dad's briefcase, that I could indeed be deeply sad and equally joyful at the same time. All of my feelings are valid; they are all important and have equal rights to co-exist in my life. I do not need to lock up the emotions I find annoying or difficult. They can be overwhelming at times, but they have something to say, and I should not supress them and send them off into outer space!

I no longer need to bottle up my sadness, my anger and my grief any more. I can hold them together and be with all my feelings and still be me.

When Mum came back and saw me crying, she said, 'Your dad never knew how to express it, but he was always very proud of you and your achievements. He wanted you to be a doctor so he would never have to worry about your future. But he knew you had discovered your own path in life and that it was OK if you didn't want to follow his. He loved you very much. He just never said it out loud.'

What is your definition of success? Are you striving for your own version of success or somebody else's? Who do you appreciate and respect most in your life? Do they know how you feel? Have you told them? Don't leave it until it is too late.

Part

4

Further
Reading and Tools

Asking for Help and Accepting Help

I am still learning how to ask for and receive help comfortably. *Go To Help: 31 Strategies to Offer, Ask For, and Accept Help* by Deborah Grayson Riegel is one of the best resources. It's practical and fun, and Deborah is an inspiring woman. I also love how she co-authored this book with her daughter, Sophie. For those of us who have struggled to ask for help, this book has helped me to develop what Deborah calls 'help-fluency': the ability to articulate the kind of help I need and accept that help when offered without feeling bad, weak or vulnerable.

Being a Boundary Boss/Saying No With Kindness

Terri Cole is the expert in setting boundaries. I love how her work is so empowering and how it creates confidence. One of the key messages of this book is that many of us have been raised to be more compliant than assertive. Most of us were never taught the language of healthy boundaries – not in school, not in university and not even at postgrad level. So how can we possibly know something that no one has ever taught us? I love the fact that we can go on to learn gentle self-compassion to change the ways in which we relate to boundary setting, and become more comfortable with asserting our preferences, our desires, our limits and our deal breakers with ease and grace. Terri offers many examples of how to do this elegantly, confidently and clearly.

Her work has allowed me to ground myself with the knowledge that I have the right to be seen and heard – to be accurately known. Ultimately, it's my boundaries (my preferences, my desires and my limits) that make me unique – they're just like fingerprints.

Terri Cole's *Boundary Boss: The Essential Guide to Talk True, Be Seen, and (Finally) Live Free* and her companion

workbook, *The Boundary Boss Workbook: The Right Words and Strategies to Free Yourself from Burnout, Exhaustion and Over-Giving*, will help you to develop boundary-setting muscles with kindness. The workbook includes tons of assessments, scripts and embodiment exercises to help you integrate boundary setting into your everyday life.

Creating Your Communities

It is no coincidence that Maslow's hierarchy of needs involves the basic need to connect and belong – we need our tribes to survive. As an entrepreneur, it is even more important to surround yourself with people who have similar values to your own. There are many ways to find them, and I'm incredibly blessed to belong to many of these communities, who support my journey and my learning:

- » Association of Coaching
- » EMCC
- » ICF
- » Female Entrepreneur Association
- » Female Founder Collective
- » 100 Women in Finance
- » The Girls' Club
- » Kea New Zealand and New Zealand Women's Business Network
- » Elizabeth Gilbert's Substack community, whom she refers to as Lovelets (we practise something Liz taught us about writing Letters from Love)
- » iEQ9 Enneagram Coaching & Facilitation Peer Group

Creativity/Time to Play

If you are interested in exploring your creativity and inner child in a fun way, I would strongly recommend Elizabeth Gilbert's *Big Magic* and Julia Cameron's *The Artist's Way*.

Journaling in any form is proven to be a very powerful form of stress relief. If you are not into meditation, perhaps start with journaling your thoughts – no one needs to see your journal; it's your own private form of self-expression.

Desire Map & Heart-Centred Leadership

One of the earliest teachers to help me with emotional intelligence and the art of connecting to my feelings is Danielle LaPorte. I found her gentle but deeply reflective work on core-desire feelings and creating goals with soul very powerful. I follow her work and have even been trained by her to become one of 350 global heart-centred leaders and facilitators, who use her tools for resilience and reflective living to empower the people we serve.

I recommend you read: *The Desire Map: A Guide to Creating Goals with Soul* or *The Fire Starter Sessions: A Soulful + Practical Guide to Creating Success on Your Own Terms*.

Emotional Freedom Technique (EFT) or Tapping

I have been an EFT practitioner for over ten years, and it has supported me through many challenging situations. I would highly recommend looking at EFT or Havening as a form of self-soothing. They are psychosensory therapy techniques that you can safely and easily do on your own (unless you have severe complex PTSD). They are designed to reprogramme the brain, to detraumatise the memory and remove negative effects from both your psyche and your body. A vast amount of research supports

the power of tapping as a brain-rewiring technique, to regulate your nervous system, boost your immune system and reduce stress and anxiety. I learnt from Jessica Ortner and Nick Ortner, author of *The Tapping Solution*.

Enneagram

I have found the Enneagram to be one of the most powerful mirrors of our unconscious motivations and ways of being. The word comes from the Greek ἐννέα (ennéa, meaning 'nine') and γράμμα (grámma, meaning something 'written' or 'drawn'). It is a model of human psychology that represents one of the nine personality types, characterised by a unique combination of the strengths, weaknesses, motivations, fears and triggers that shape our thoughts, feelings and actions. It is a brilliant tool for better understanding ourselves and others, as well as for self-discovery and spiritual growth. It can be used to develop individuals as well as improve communication and relationships between partners and within teams. I highly recommend learning from Integrative Enneagram Solutions; their iEQ9 Questionnaire is the most accurate in the market.

Family/Systemic Constellation Therapy

'Family/Systemic Constellation Therapy is a short-term group intervention that aims to help clients gain insights into and then change their inner image of a conflictual system and finally change their behaviour in relation to that same system' (Konkolÿ Thege, B., Petroll, C., Rivas, C., & Scholtens, S. 2021).

The effectiveness of family constellation therapy in improving mental health: A systematic review. *Family Process*, *60*(2), pp 409–423.

I found the experience very healing and it helped me to see some of the unconscious dynamics within my own family system and understand more about some of my family's behaviours and beliefs. I have been working on this alongside my ACT practice and forgiveness journal. While research is limited, existing studies suggest that constellation therapy offers a potentially effective treatment for clients: 'It provides ... unique opportunities for powerful emotional releases, positive behavioral change, and deep insights into themselves, their relationships, and their shared past' (Konkolÿ Thege et al., 2021).

Greater Than the Sum of Our Parts/Internal Family Systems (IFS)

IFS, developed by Richard Schwartz, is a kind of therapy that addresses the conflict between the parts in our mind. I found it very powerful for uncovering aspects of myself, and it is now part of the language I use to help my clients work on their parts: how each of them can be triggered or activated, what their core functions are and why they show up. This is particularly helpful if you struggle to regulate your nervous system when old traumas arise. You might also benefit from the work carried out on complex trauma by Dr Frank Anderson.

You can get more information from the IFS Institute or by reading any of Dr Richard Schwartz's books and Dr Frank Anderson's *Transcending Trauma: Healing Complex PTSD with Internal Family Systems Therapy* and his latest work *To be Loved: A Story of Truth, Trauma and Transformation*.

According to Richard, the goal of IFS therapy is to help the individual resolve conflicts between their parts so that the person can live life from its core self, which is compassionate, wise and confident.

Grief Counselling and Finding Meaning

Healing from grief and loss – who would I be without my father's and my grandfather's love and guidance? Through journaling and meditation, I was led to take my love for my dad and grandpa and spread it around. This change has allowed me to free myself of the grief and guilt, so I can be open to new possibilities.

Grief is powerful, but one thing I know about grief is it comes in waves. One thing I know about waves is they pass.

I recommend *Finding Meaning: The Sixth Stage of Grief* by David Kessler.

Healing Trauma in Body and Mind

Develop a practice that connects you with your mind, body and spirit, so you can listen to what they are trying to tell you. You can start by doing simple body scans meditation, where you focus on your body. Mentally scan from the top of your head all the way down to the tips of your toes, noticing different sensations – physical and emotional – or meditate and visualise yourself, talk to your parts. Your mind is strongly linked to your body, and you can ask yourself questions. What's not working? How can I change my physiology to change my state? What can I do in this situation? Then listen. Be open to signs and answers and follow the proverbial White Rabbit of signs and answers. Ask yourself questions before you go to bed and allow yourself to be curious – *cure* is in the word *curious*. This is your body's wisdom helping you to discover the path to recovery.

Sometimes, we are used to being on autopilot, and we get stuck with a certain way of looking at our challenges. It helps to step outside yourself and incorporate regular self-reflective practices. Are you resisting something?

What is it? Forgive yourself for resisting and allow solutions to come. Ask yourself what else this could mean? What other stories can you tell yourself? Can you find a different perspective, one which will help you to think in a different way and reframe the situation?

Recognise that so much of our anxieties and fears are not real. Our brains are wired to protect us from the unknown and unfamiliar, so if there is something you would like to work on (e.g. public speaking), perhaps try to find a way to reframe the meaning you have given to your trigger (e.g. microphone = death by embarrassment); slowly train your brain to become familiar with it in a fun, non-scary way. For example, a microphone is not only used for public speaking but also for karaoke with your friends. When your brain becomes more familiar with such symbols in a non-threating environment, you can then manage your anxieties within those safe settings.

There are many techniques that can help you to shift your attention from fight or flight towards the calm and creative. Rick Hanson's *The Buddha Brain* and his work on positive neuroplasticity are some of the most fantastic resources. I also recommend Peter Levine's work on Somatic Experiencing and his book *Healing Trauma: Restoring the Wisdom of Your Body*, and *The Body Keeps the Score* by Bessel van der Kolk.

Start paying regular attention to your body's signals. Don't ignore them, thinking they will go away. The body keeps score, and it doesn't go away. If you ignore your body, it will speak up, louder and louder each time until you give it your attention. By the time it's yelling at you, like it did with me, you will have reached burnout. So why not pay attention before you get there. I find preventative methods are always easier and better. So don't wait. Listen to your body – to your gut feeling. That's your intuition talking to you through your body's signals. Recognising

these signals will not only prevent burnout but it might also save you from many other disasters.

High-Performance Habits

Brendon Burchard is a no-nonsense, high-performance coach, and I have particularly enjoyed his book *High Performance Habits*, which is based on quantitative research. This book demonstrates that the key to success is rooted in six core habits, and it includes tips and advice on how to cultivate and elevate each habit:

1. Seeking clarity
2. Generating energy
3. Raising necessity
4. Increasing productivity
5. Developing influence
6. Demonstrating courage

Listening to Your Intuition

We all have innate, intuitive abilities; we just might not know how to access them. If you are interested in practical ways to tap into your intuition, I recommend the work of Laura Day and Sonia Choquette.

Money Belief and Mindset

I believe our money mindset goes far beyond how we earn, keep and spend money. It affects how we see the world, and how we value ourselves and others. I have been working on my money beliefs, reflecting on where they came from, how my parents behaved, what their parents experienced and how we can act very differently, depending on whether our general mindset is abundance based or scarcity based. If you would like to find out more, I recommend Lynne Twist's *The Soul of Money* and Kate

Northrup's *Money, A Love Story: Untangle Your Financial Woes and Create the Life You Really Want.* In addition, try Denise Duffield-Thomas's *Get Rich, Lucky Bitch! Release Your Money Blocks and Live a First-Class Life* and David Bach's *The Automatic Millionaire: A Powerful One-Step Plan to Live and Finish Rich.*

Morning Rituals & Evening Rituals

I am a huge believer in setting my days up for success, and that includes an evening ritual of clearing my mind before going to sleep, meditation and keeping a gratitude journal. My routine also involves self-care (hygiene and skincare, including face yoga), gentle somatic movements and stretches on my PEMF (pulsed electromagnetic field) mat. I finish with a mantra to prepare my unconscious for a restful sleep.

Upon waking, I follow a modified version of Hal Elrod's Miracle Morning, with transcendental meditation, affirmation and visualisation, morning tai chi, reading, and writing my Morning Pages. For more about morning routines, you can read Hal Elrod's *The Miracle Morning: The Not-so-Obvious Secret Guaranteed to Transform Your Life (Before 8am).*

Positive Intelligence Research

This research looks at ten negative response factors (ten 'saboteurs') and five positive response factors (five 'sage powers') and how these root-level factors affect our performance and wellbeing. It is based on research that uses a metric called PQ (positive intelligence quotient or positivity quotient), which measures the relative strength of your positive versus negative mental muscles, and trains you in improving your positive mental muscle so you won't self-sabotage. The voices in our heads generate

negative emotions, and I have really enjoyed learning about how to manage my saboteurs, from Shirzad Chamine of Stanford University.

See www.positiveintelligence.com/science/

Positive Neuroplasticity

I have had the pleasure of training with Dr Rick Hanson, and I recommend you start with his book, *Hardwiring Happiness*. It contains a simple yet effective four-step process to beat our brain's negativity bias. It incorporates lots of easy-to-use exercises to grow your self-worth, inner peace and wellbeing. I also love his podcast *Being Well*, which is very educational and easy to follow, even for non-practitioners.

See www.positiveneuroplasticity.com

Self-care Practices

As I mentioned earlier, I have been refining my own daily and monthly rituals to support my wellbeing; a large part of this has been to recognise that rather than being a selfish exercise, self-care is a way of looking after myself so I have the capacity to look after others.

Self-care to me is not just about having a bubble bath, it is the holistic need for my mind, body and soul to exist sustainably while also being a regime I can maintain.

1. Exercises – Cardio, weight training and core strength and flexibility
2. Sleep – good sleep hygiene and monitoring how well you sleep and what factors affect your sleep quality
3. Nutrition – learning about the foods that fuel you; preparing fresh food and minimising highly

processed food; and understanding how food can really impact your energy levels. Listen to your body and your future self will thank you

4. Spiritual practice – whatever you believe in that helps you to connect with the greater good
5. Therapy – appropriate counselling and at a frequency you can afford
6. Brain gym – continuous learning and mind challenges to reduce your risk of neurodegenerative diseases
7. Somatic work, self-regulation and meditation – whether it is EFT, somatic movements, breathwork or meditation; whatever helps to calm your nervous system

Self-compassion/Acceptance Commitment Therapy (ACT)

I am a huge fan of ACT as a form of healing. If you would like to find out more, I recommend Russ Harris's *The Happiness Trap, The Reality Slap* and *Act Made Simple*. In addition, try Tara Brach's *Radical Compassion* and Kristin Neff's *Self-Compassion*.

Shame

Brené Brown has helped me to understand many of my emotions in a gentle and empathetic way, particularly around the area of shame and guilt. Her books are very powerful, but I refer regularly to one in particular: *Atlas of the Heart*. She offers so much clarity on our emotional landscapes and has given me the vocabulary to articulate these complex feelings. I was not shamed by my teachers, even though I really struggled with English when I first moved to New Zealand, but I was shamed by my brother for asking stupid questions, for not knowing the meaning

of various aspects of English vocabulary. The negative interactions, particularly when we had fights or when he was asked to stay home to look after his little sister, would come out through name-calling and other cruel practices. This might have been an outlet for his unexpressed anger towards my parents for making him the de facto adult in our household because he was fluent in English and already taller than Dad by the age of fifteen.

See also *Daring Greatly* and *The Gifts of Imperfection* by Brené Brown.

The Drama Triangle by Stephen Karpman

This is a powerful framework through which to understand the dysfunctional roles we tend to adopt when dealing with conflict. The drama triangle provides an escape path for us to hide our underlying feelings, and it prevents us from addressing our real problems. Provoked by a personal conflict, dysfunctional drama arises when we latch onto one of the three roles of the drama triangle that binds us within a codependency trap as we switch between the different points of the triangle.

There are three roles in the drama triangle, each one represents the flawed thinking connected to our desire to be right: victim, persecutor, rescuer.

Have you ever assumed the role of victim, believing you have been wronged and feeling sorry for yourself? Perhaps you've played the role of persecutor, blaming others for the problems you are facing? Or maybe you've tried the role of rescuer, feeling that you must save others?

None of the three roles allows you to be resourceful, and they each lead you to surrender your power. How can you step out of these roles and honour the struggles you have faced? How can you bear witness with detachment and forgive yourself and others for what has happened,

so that you can step out of the triangle, regain your power and move on?

The story you have been living in your head no longer serves you. Yes, shit has happened, and it might or might not be your fault, it might or might not be within your control, but you absolutely have full control over how you respond to the situation. So, choose – choose yourself, choose freedom and choose to rewrite the story into one that allows you to feel empowered, let go and move on.

Women's Health & Wellbeing

My mum and my grandmother never had the resources nor the access to the wealth of information we now have at our fingertips. I want to not just live longer but I also want to live well, be mobile and have a level of vitality that allows me to enjoy my life to the fullest. This includes reading medical research on women's health, nutrition and a fasting lifestyle, biohacking, sleep and the impact of hormonal health during menopause.

I recommend Dr Lisa Mosconi's *The XX Brain* and *The Menopause Brain*. In addition, try Dr Mindy Pelz's *Fast Like a Girl* and Caroline Criado Perez's *Invisible Women*.

About the Author

Victoria Liu is a Cambridge-trained Master Executive Coach. With over two decades of experience in senior roles at global corporations, including BlackRock, Deutsche Bank and the NHS, Victoria has honed a unique approach to leadership development.

Committed to empowering 'unconventional' leaders, Victoria specialises in helping introverts, neurodivergent individuals and migrants unlock their full potential in the corporate world. Her Quiet Perseverance framework, born from personal experience and professional insight, guides often overlooked leaders to flourish in environments where others might dominate.

Victoria has coached, trained and consulted for more than 4,000 global leaders across a wide range of sectors. Her client roster includes executives from industry giants, such as Google, IBM and Morgan Stanley, as well as regulatory bodies, like the Financial Conduct Authority.

Victoria's expertise spans change management, high performance and mental resilience. She is particularly adept at helping technically skilled professionals to develop the people skills crucial for effective leadership.

Drawing on her journey as an introverted immigrant who rose to leadership positions in highly competitive environments, Victoria is dedicated to redefining what powerful leadership looks like. Through her work, she demonstrates that success doesn't always shout – sometimes it perseveres, quietly.

Victoria's multicultural background and multilingual skills enable her to connect with leaders from diverse backgrounds, fostering inclusive and innovative leadership practices in today's global business landscape.

When Victoria's not coaching, she can be found travelling and sampling local cuisine, if not on her couch writing, reading or learning something new.

For more information about Victoria, please visit www. victorialiu.com, or you can connect with Victoria on Instagram @victorialiucoach

Acknowledgements

They say it takes a village and it's never been truer!

I want to start with thanking my family for their unconditional love and support throughout this writing journey on which I have learnt about all the different team members I needed to create my book.

The team at UK Design Co, my amazing friend Oliver, your kind words and support have got me through multiple potentially disastrous panic attacks. To Simon for your wisdom and guidance. My unbelievably talented and patient illustrator, Tamas, who not only read my mind but who also interpreted my doodles and descriptions tirelessly; I never knew what a truly wonderful collaboration felt like until I worked with you. To Inka for sharing your profound knowledge in book binding and layout.

To Steve for encouraging me to start writing and keep writing; you never failed to say the perfect words to make me feel safe to be me and share my stories. To Judith, you are like the fairy godmother every girl dreams of. To Angelita for not letting my desire to be humble and liked allow me to accept more s**t.

To my incredible group of pilot readers, your generous feedback has helped me to create the book it is today. To Carrousel Studio for helping me in areas where I didn't even know I needed help.

To all the managers I have had, without you I wouldn't have developed my own style of leadership and challenged myself to be better every single day.

To my coach, Jeremy, for showing me what a magnificent coach can do to change someone's life. You are the reason I decided to train in this field and thereby discover my life's work. To all my past and current

coachees, mentees and clients for giving me the gift to witness your journeys, and giving me the opportunity to learn and grow with you.

To my awesome community of entrepreneurs, coaches, trainers, teachers and facilitators around the world, I'm so blessed to have you in my life.

Finally, I would like to thank my friends for putting up with me for the duration of the writing of this book.